IMAGES
of America

PUEBLOS OF
NEW MEXICO

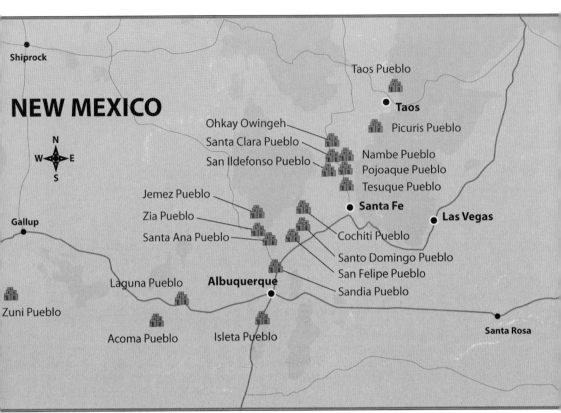

The 19 Indian pueblos of New Mexico and their settlements along the Rio Grande are detailed on this map. Settlement in this region began as early as the 12th century. The Tiwa language is spoken in the northern and southern pueblos, while the people of the Middle Rio Grande region speak the languages of Tewa, Towa, and Keres. People of the Zuni Pueblo, located to the west, speak their own language of Zuni. (Western Art Collector.)

IMAGES
of America

PUEBLOS OF
NEW MEXICO

Ana Pacheco
Foreword by Brian Vallo

ARCADIA
PUBLISHING

Copyright © 2018 by Ana Pacheco
ISBN 978-1-4671-2942-8

Published by Arcadia Publishing
Charleston, South Carolina

Printed in the United States of America

Library of Congress Control Number: 2018931210

For all general information, please contact Arcadia Publishing:
Telephone 843-853-2070
Fax 843-853-0044
E-mail sales@arcadiapublishing.com
For customer service and orders:
Toll-Free 1-888-313-2665

Visit us on the Internet at www.arcadiapublishing.com

To the Pueblo People of New Mexico from the past, present, and future.

CONTENTS

FOREWORD

For Pueblo people, the memory of time passed—of emergence, migration, and ancestors—remains embedded in mind and spirit. Carefully crafted stories emerge from this sacred memory and serve as a means for offering future generations insight into the time of creation and of the enduring lifeway that has sustained Pueblo people for millennia. These stories, recounted during the frigid months of winter among families, clan groups, and societies, are critical to the continuance of Pueblo culture. This trained mind's eye—lens, if you will—serves as the source for maintenance of history, cultural values, and language, and informs a process for envisioning the future.

Fast forward, acknowledging a history fraught with challenge and trauma resulting from Spanish contact and establishment of the United States, and interest in Native American people of the Southwest emerged and influenced initiatives by both the federal government and academia to research the ethnography of Pueblo people. This widespread inquiry produced documentation that, for the very first time, offered insight into Pueblo culture and history. The use of a new technology to capture imagery also emerged and was utilized to document aspects of Pueblo life and ceremony during this time, and of places along the Pueblo migration. This exposure prompted a wave of interest and inquiry into Pueblo culture. To the credit of some federal agents, ethnographers, and photographers, the imagery captured over several decades has become important and useful to Pueblo communities in their efforts to protect resources and to revitalize cultural practices, language, and traditional arts.

Today, while most Pueblo people maintain stringent policies for photography and often limit access of non-tribal members onto their lands, some do offer opportunities in accordance with tribal policy and needs of the community. Pueblo people have also accepted photography as a means of documenting tribal and personal histories. There is a growing interest among Pueblo people to expand their own lens in order to ensure that future generations can reflect on and know their rich history while utilizing technology to document contemporary Pueblo life, deeply rooted in cultural core values instilled in the collective Pueblo memory.

—Brian Vallo, Acoma Pueblo
Director, Indian Arts Research Center at the School for Advanced Research

ACKNOWLEDGMENTS

I am forever indebted to the staff at the Museum of New Mexico Palace of the Governors Photo Archives for their continual help and expertise. As the caretakers of more than one million images, their job in preserving history is not without challenges.

It is an honor to have Brian Vallo's foreword included in this book. As a member of Acoma Pueblo and the director of the Indian Arts Research Center at the School for Advanced Research, Brian's years of expertise and knowledge inspired me along the way.

I am also grateful for the input provided by Dr. Matthew J. Martinez. Dr. Martinez is currently serving as lieutenant governor at Ohkay Owingeh. He received his Ph.D from the University of Minnesota and continues to document and publish in the areas of New Mexico and Pueblo histories.

Special thanks to Allison Colborne, library director for the Laboratory of Anthropology Library at the Museum of Indian Arts and Culture. When I began this book, I sent an e-mail to Allison with an outline of topics that I needed. *Voila!* The day I arrived at the library, a stack of books was waiting for me.

I would also like to make mention of the fact that the Laboratory of Anthropology Library is one of only twelve institutions in North America that has a complete set of *The North American Indian* by Edward S. Curtis—all 25 volumes. Due to time constraints, I was only able to browse through two volumes of this historical treasure. I have made a mental note to add future visits to the library to review the entire literary masterpiece to my bucket list.

Royalties from the sale of this book will be directed to the Chamiza Foundation. Its mission is to ensure the continuity and "living" preservation of Pueblo Indian culture and traditions.

INTRODUCTION

The Pueblo Indians of New Mexico are believed to be descendants of the Ancestral Puebloans (Anasazi), who populated the Four Corners region of Utah, Arizona, New Mexico, and Colorado. During the 12th century, the Pueblos began settlements along major rivers, primarily the Rio Grande, which begins in south-central Colorado and flows to the Gulf of Mexico. Francisco Vasquez de Coronado was the first explorer to come into contact with New Mexico's indigenous population at Zia Pueblo in his 1540–1542 expedition. San Juan Pueblo (in 2005, the pueblo went back to its original name, Ohkay Owingeh) was the first settlement claimed by Spanish explorer Juan de Oñate in 1598. The next significant date in the history of the Pueblo people occurred in the latter part of the 17th century during the Pueblo Revolt of 1680. Led by the medicine man Po'pay of Ohkay Owingeh, the neighboring pueblos drove the Spanish colonists out of New Mexico for 12 years.

The opening of the Santa Fe Trail in 1821 from Franklin, Missouri, to Santa Fe introduced New Mexico's Pueblo population to those ambitious men and women who braved the trade route. But it was the coming of the railroad in 1878 that opened the floodgates, with people arriving from the East, including archeologists and anthropologists. In New Mexico, they hit pay dirt—they no longer had to travel to exotic destinations to study aboriginal societies. Another group that shared in this serendipitous discovery was early photographers.

In 2017, I wrote *Early Santa Fe* for Arcadia's Images of America series. The history of this nation's oldest capital city was documented in that book through the work of the photographers who began to arrive around 1850 on the Santa Fe Trail and, later, the railroad. While doing my research at the Palace of the Governors Photo Archives, I discovered that many of these photographers had also captured the earliest images of New Mexico's 19 Indian pueblos. Since my focus was just on Santa Fe, I knew that another book had to be written that provided a platform for the extensive oeuvre of these creative, adventurous, and most certainly determined photographers.

Photographs by Ben Wittick, Dana B. Chase, George C. Bennett, William Henry Brown, T. Harmon Parkhurst, Jesse Nusbaum, Charles F. Lummis, Christian G. Kaadt, and Aaron B. Craycraft appear in this book. Since my focus for *Pueblos of New Mexico* was to document the earliest images of the pueblos starting in 1866 and ending in 1925, some of the other photographers from *Early Santa Fe* are not included here. Those include John Candelario, whose photographs of the pueblos began in the 1940s. I also did not include the wonderful images by Laura Gilpin, since her work came later and focused primarily on the Navajo nation. I chose the cut-off date of 1925 because many books on the pueblos have been written, and I wanted to provide exposure to the earliest images that may not otherwise see the light of day, save for an occasional researcher or academic. Also, it is my hope that in writing this book that the descendants of some of the people featured may be recognized. I reviewed over 1,000 photographs prior to choosing the ones featured in this book, trying to use the ones where people are identified. I also chose to group each pueblo by language and region from north to south, as shown in the map on page 2.

Other photographers featured are the anthropologist Mathilde Coxe Stephenson and the Western photographer Adam C. Vroman. Readers will find an occasional image by a lone photographer who I felt warranted inclusion. To my utter delight, more than 50 photographs by Edward S. Curtis are featured. Several books and articles on Curtis have been published; his work has also been featured through ongoing exhibits. His photographs continue to be in circulation and are cherished by ardent collectors of Western art. His most crowning achievement was the colossal *The North American Indian*. Published at the beginning of the 20th century, the 25-volume series features over 2,000

original photographs. Each volume contains at least 75 photographs and 200 pages of text, which Curtis compiled. Today, this remarkable series can be found in public and private collections around the world and is valued at over $1 million. Like the early scholars who studied this region, I hit the jackpot at the Palace of the Governors Photo Archives with its collection of Curtis photographs.

Edward S. Curtis was an ethnologist and photographer. He was born in 1868 in Whitewater, Wisconsin. At the age of 32, married and with a family, he decided to embark on the biggest adventure of his life. His mission was to preserve the dignity of the proud people that he first encountered in 1900. With unparalleled self-confidence and zeal, Curtis obtained the financial support of the financier J.P. Morgan. Pres. Theodore Roosevelt and the royalty of both England and Belgium encouraged him to document his work. In addition to over 50,000 negatives, he recorded Native American languages and music, and filmed the first moving images of American Indians. From 1900 through 1930, Curtis was dedicated to capturing Native American culture. In those three decades, he provided an indelible commentary on the lives of the indigenous people of the United States and Canada like no other photographer of that era.

As a publisher, editor, and writer of New Mexico history for the past 25 years, I have learned much about this region. However, I believe that it was growing up in Santa Fe, possibly through osmosis, that my work has truly come together. For all of us who call New Mexico home, the state's three predominant cultures—Native American, Hispanic, and Anglo—have always been intertwined. My neighbors growing up were from some of the surrounding pueblos, as were some of the kids I played with at school. But it was not until I began researching this book that I realized how profound the roots of culture overlap. When I was born in 1956, my parents, Jesus and Natalie Pacheco, were living in the small community of Pajarito, on the southern outskirts of Albuquerque near Isleta Pueblo. They attended San Augustine Church on the pueblo, where I was baptized. My mother often recounted the unpleasant events that occurred at my baptism. On that day, I happened to be the only non-Pueblo baby being baptized, but that was not why my parents were singled out. It was because of my godparents, Cleofas and Beatrice Garcia. As they brought me to the altar, the priest criticized my uncle for his first name, blurting out, "What kind of a Christian name is Cleofas!" My parents and godparents were visibly shaken and distraught on a day that should have been joyous. That memory from 61 years ago came home to roost for me as I read about the history of Isleta Pueblo.

In 1955, a German priest, Msgr. Frederick A. Stadtmueller, was assigned to the San Augustine parish. According to reports, he had great disdain for the Pueblo people and their traditions. He did not approve of their burial practices, which consisted of burying the dead in a blanket soon after their passing. The priest also rejected the Pueblos' ceremonial dances and paved the area where they took place with asphalt, though he knew that the Pueblos considered it sacred ground. For the next 10 years, he continued to alienate the parishioners; by 1965, they had had enough of his draconian leadership. In an unheard-of turn of events after three centuries of submission to the Catholic Church, the people of Isleta banded together to have the priest ousted from the pueblo. However, the priest refused to leave and had to be forcibly removed by the police in handcuffs. The photograph of his arrest and expulsion from the pueblo was featured in the April 1965 issue of *Life* magazine. That notorious priest was the very same one who insulted my family at my baptism, an event that haunted them for the rest of their lives.

As the author of this book, I think it is important to provide full disclosure: My mother's family played a significant role in the 1692 Reconquest of Santa Fe. Her grandfather, several times removed, was Nicolas Ortiz, the lieutenant and second in command to Diego De Vargas who led the resettlement efforts. Ortiz married Gertrudis Paez Hurtado, the daughter of Juan Paez Hurtado, the right-hand man to Vargas. It is no secret that even after the Pueblo Revolt, the Spaniards continued to mistreat the Pueblo people. The cascading narrative of rape, torture, and servitude came up over and over again in researching this book, not just by the Spaniards, but by the American government as well. That is an aspect of my heritage that I am not proud of, but rather than dwell on it, I believe it is important to document elements of New Mexico's history that provide encouragement. The ongoing fortitude of the proud Pueblo people of New Mexico, who have been subjected to adversity for the last four centuries, is an inspiration to all.

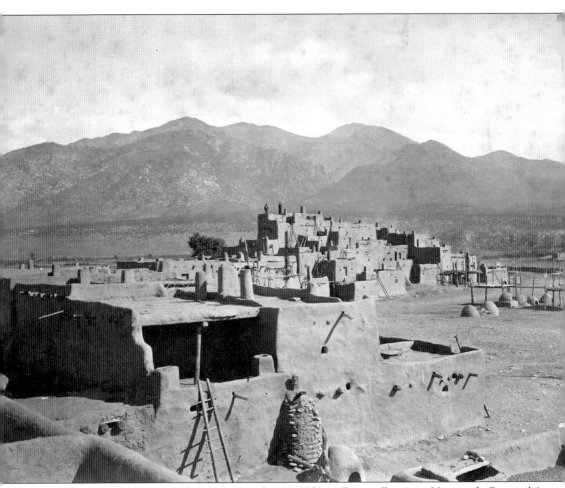

The settlement of Taos Pueblo began around 1200–1250 AD. During Francisco Vazquez de Coronado's expedition in 1540, Spanish explorers first encountered the multi-story dwellings, synonymous with New Mexico's northernmost pueblo, at Taos Pueblo. The dwellings would become world-famous. This c. 1880 photograph is of the South Plaza at Taos Pueblo. (Photograph by Bennet and Brown, Palace of the Governors [NMHM/DCA], No. 147381.)

One

NORTHERN TIWA PUEBLOS

Taos Pueblo is the northernmost of the pueblos along the Rio Grande. With only 70 Spaniards living in the immediate area from 1598 to 1680, the pueblo was spared the constant scrutiny of the colonists. But they too were affected by the injustices of the Spanish crown and joined the neighboring villages during the Pueblo Revolt of 1680. As history has shown, that would not be the last battle for Taos Pueblo.

Behind the world-famous multi-storied pueblo sits the Taos Mountains and the pueblo's sacred Blue Lake. In 1906, the US Congress designated an area of the Rocky Mountains that included part of the Taos Mountains a national forest. The federal "land-grab" included Blue Lake. The Pueblo protested, but their voice was not heard for 64 years until 1970, when 48,000 acres were returned, including Blue Lake.

The Spanish explorer Gaspar Castaño de Sosa was in awe when he stumbled onto Picuris Pueblo, a small community nestled in the mountains, in 1591. Its beautiful surroundings were beyond perfection as far as he was concerned. But seven years later, Juan de Oñate came upon the pueblo and thought it should be called San Buenaventura; fortunately, the name did not last long.

Picuris Pueblo also participated in the Pueblo Revolt, and tensions persisted into the next century. In 1696, the pueblo was abandoned, and the people of Picuris lived among the Apache groups on the plains for the next decade. The exiles returned in August 1706 to resettle the pueblo.

Four hundred years after its first identity crisis, in 1947, some Picuris Pueblo members decided to change the name to the Pueblo of San Lorenzo. Apparently, naming the pueblo for a saint first introduced by the Spaniards did not go over well, and by 1955, the name was changed back.

Taos and Picuris Pueblos speak Northern Tiwa, a language most closely related to an extinct language of the Piro Indians. These two northern New Mexico pueblos continue to show their tenacity and fortitude in defending their rights, ensuring that they will never die out.

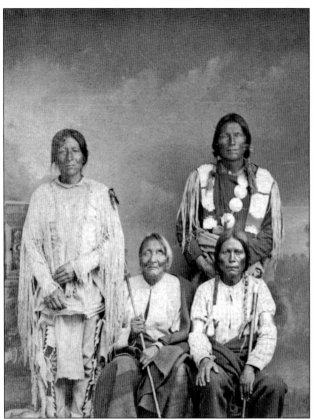

The Taos Indians played an active role in the 1680 Pueblo Revolt that successfully drove Spanish colonists out of New Mexico for 12 years. A group of Taos Pueblo Indians pose for this c. 1866 studio photograph. Studio photography began in New Mexico in the 1860s and proliferated with photographers like Ben Wittick by the 1880s. (Photograph by William Henry Brown, Palace of the Governors [NMHM/DCA], No. HP.2012.26.6.)

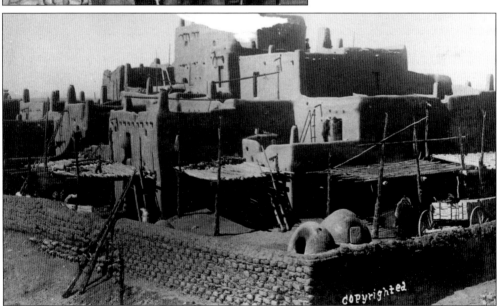

The wagon and *hornos* (beehive ovens) in this c. 1884 photograph were introduced to the pueblos by Spanish colonists. During the colonial era from 1598 to 1680, only 70 Spaniards lived in the area, providing Taos with more freedom than the pueblos to the south. (Photograph by Dana B. Chase, Palace of the Governors [NMHM/DCA], No. 004594.)

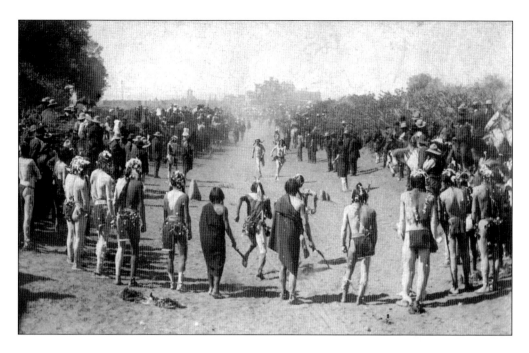

San Geronimo is the patron saint of Taos Pueblo, whose Catholic feast day is celebrated on September 30. Each year, the festivities include a foot race like the one shown above around 1884. Below, the Catholic community of the city of Taos gathers at the pueblo feast day celebration to honor St. Jerome around 1884. (Above, photograph by Dana B. Chase, Palace of the Governors [NMHM/DCA], No. 037205; below, photograph by Dana B. Chase, Palace of the Governors [NMHM/DCA], No. 057017.)

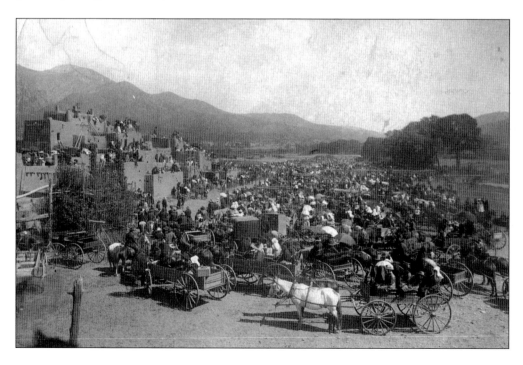

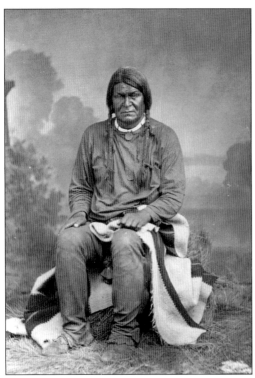

Many of New Mexico's Pueblo people were given Spanish names during the colonial era. Most of the adopted surnames were those of the wealthy noblemen who governed the pueblo. This photograph taken in 1881 at Taos Pueblo is of a man named Juan de Jesus Romero. (Photograph by William Henry Brown, Palace of the Governors [NMHM/DCA], No. 087553.)

Known as "Gold Tooth John," this man posed for this c. 1905 photograph in front of Taos Pueblo. His unique name may be derived from a Tiwa word, or was perhaps given to him by the photographer. (Photograph by Aaron B. Craycraft, Palace of the Governors [NMHM/DCA], No. 002130.)

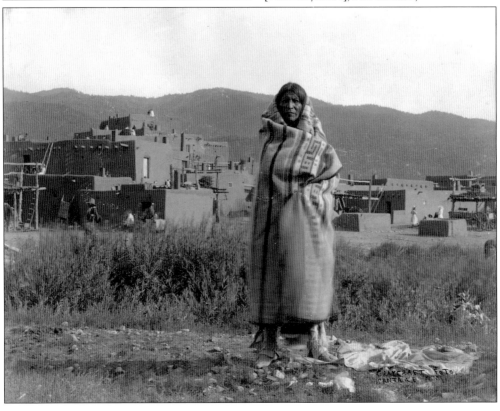

Parabea, a young girl from Taos Pueblo, was photographed in 1905 wearing a traditional necklace and earrings. The head scarf became common for Pueblo women and was influenced by the Spanish customs brought to the pueblo during the first colonial settlement in 1598. (Photograph by Edward S. Curtis, Palace of the Governors [NMHM/DCA], No. 144507.)

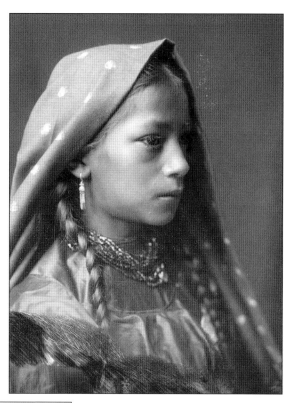

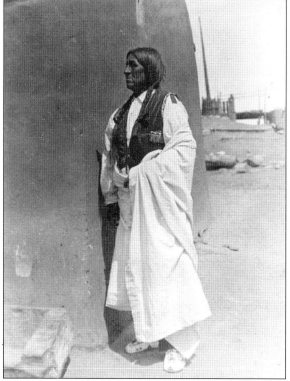

Taos Pueblo is the only New Mexico pueblo whose people regularly incorporate the use of white in their attire. This c. 1915 photograph of Manuel Pacheco shows him wearing white moccasins and draped in a white blanket. (Photograph by Carter H. Harrison, Palace of the Governors [NMHM/DCA], No. 156596.)

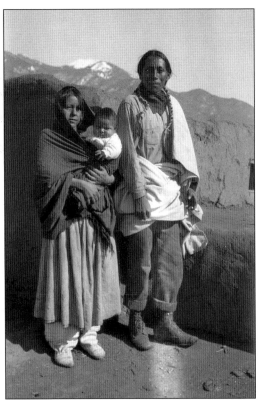

In 1906, Congress designated part of the Taos Mountains as a national forest. Taos Pueblo's sacred Blue Lake, which is located in the mountains behind the pueblo, was part of the land confiscated by the government. After decades of protesting, 48,000 acres were returned in 1970. The Taos Mountains are in the background of this c. 1919 photograph of a Taos Pueblo family. (Photograph by Jesse Nusbaum, Palace of the Governors [NMHM/DCA], No. 158114.)

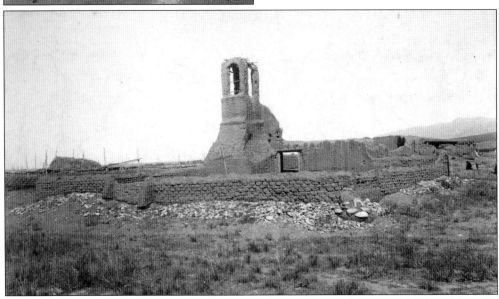

When Diego de Vargas surveyed the aftermath of the Pueblo Revolt in 1696, he found that the shell of the burned-out church at Taos Pueblo was being used as a corral. Under the guidance of Fray Juan Mirabal, the new Mission Church of San Geronimo was built in 1726. Later, the church was moved to the center of the pueblo, where it is today. This c. 1884 photograph shows the ruins of the 18th-century church. (Photograph by Dana B. Chase, Palace of the Governors [NMHM/DCA], No. 056998.)

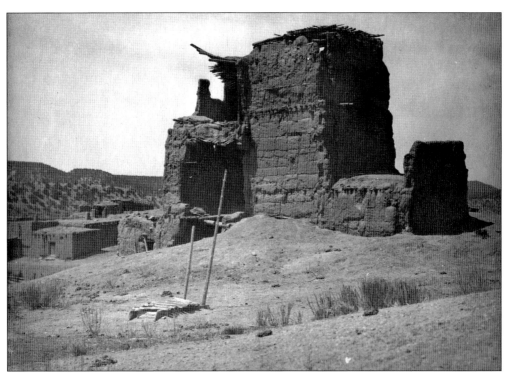

The expedition of Gaspar Castaño de Sosa was the first to visit Picuris Pueblo in 1591. Seven years later, Juan de Onate came upon the pueblo and called it San Buenaventura. Tensions between the Pueblos and Spanish settlers continued after the 1680 Pueblo Revolt, and in 1696, the Indians abandoned Picuris. For the next decade, they lived among the Apache groups on the plains. In August 1706, the Picuris exiles returned. The Castillo ruins at Picuris Pueblo, shown here around 1905, are some of the last remnants from the 17th century. (Photograph by Carter H. Harrison, Palace of the Governors [NMHM/DCA], No. 146568.)

Adobe structures are built with sunbaked bricks made of a mixture of sand, straw, and water. This c. 1905 photograph taken at Picuris Pueblo shows a typical home. The structures were warm in the winter and cool in the summer, a benefit of using materials made from the earth. (Photograph by Carter H. Harrison, Palace of the Governors [NMHM/DCA], No. 146569.)

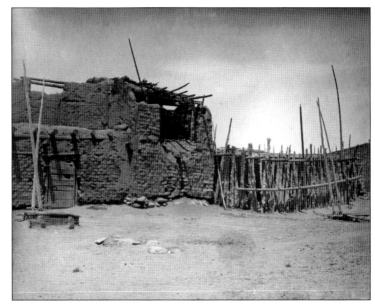

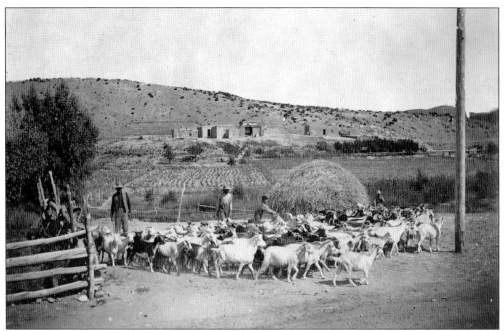

Through the 19th century, Picuris Pueblo remained a relatively self-contained agricultural community through subsistence farming, the gathering of wild plants, and hunting game animals. This c. 1915 photograph shows the process of using goats to thresh wheat. (Photograph by Ed Andrews, Palace of the Governors [NMHM/DCA], No. 015123.)

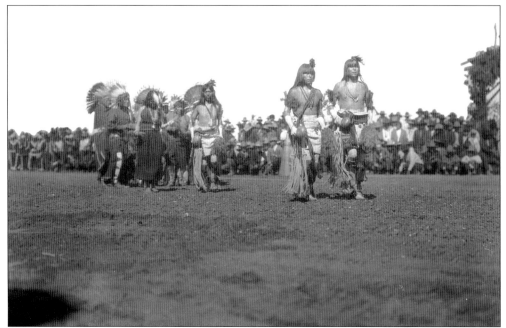

Picuris Pueblo is nestled in the Sangre de Cristo Mountains in southern Taos County. The 7,300-foot altitude limits the growing season to only 128 days. The 1925 Harvest Dance, pictured here, was held in gratitude for the year's bounty. (Photograph by Edward S. Curtis, Palace of the Governors [NMHM/DCA], No. 144698.)

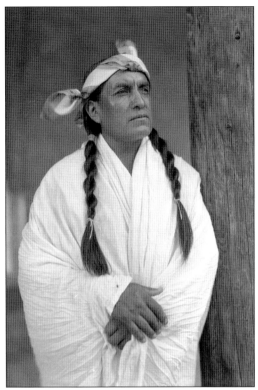

Although the Pueblo people took Spanish surnames, they continued to refer to one another by the names given to them by their parents. The c. 1925 photograph at right shows a Picuris Pueblo man known as Pah-tag-o, which means "Spotted Deer" in their native language of Northern Tiwa. Below, an unidentified Picuris Pueblo man is wrapped in a woolen blanket around 1925. During this era, men primarily from the northern pueblos traditionally braided their hair as seen in these images. (Both photographs by T. Harmon Parkhurst, Palace of the Governors [NMHM/DCA]. Right, No. 069991; below, No. 043713.)

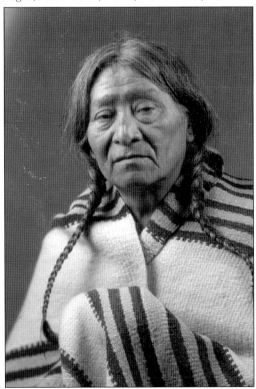

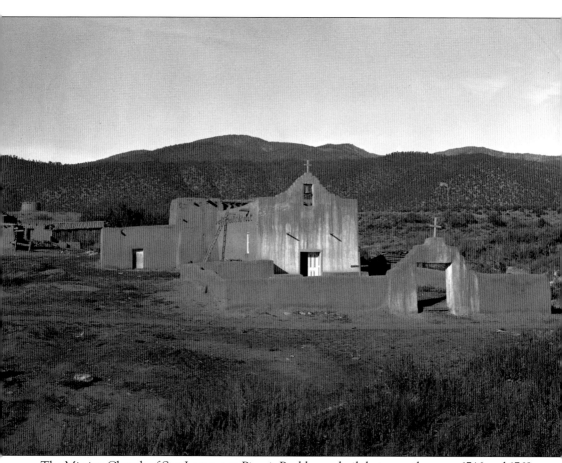

The Mission Church of San Lorenzo at Picuris Pueblo was built between the years 1746 and 1769. Soon after, it was destroyed by a group of marauding Comanche Indians. The church was rebuilt in 1776, and through the late 1800s, the area's Spanish American community also attended San Lorenzo. The church has undergone several renovations in its history; in the late 1960s, it was restored to its late 1700s appearance. San Lorenzo Church is seen in this photograph, adorned with a cross at the courtyard entrance, around 1911. (Photograph by Jesse Nusbaum, Palace of the Governors [NMHM/DCA], No. 028703.)

Two

TEWA PUEBLOS

Ohkay Owingeh, formerly known as San Juan Pueblo, was at the epicenter of events during the latter part of the 16th century that indelibly shaped the history of New Mexico. The Spanish explorer Gaspar de Castaño was the first European to make contact with the Pueblos in 1591 and was the harbinger of change. Castaño erected a huge cross at the pueblo to mark the beginning of the evangelization of the native people. When Juan de Oñate arrived in 1598, he christened the Pueblo San Juan de los Cabelleros. It was also at San Juan Pueblo that the medicine man Po'pay began the 1680 Pueblo Revolt that forced the Spanish colonists out of New Mexico for 12 years.

Santa Clara Pueblo is the third largest northern Tewa pueblo located on the west bank of the Rio Grande between Santa Fe and Taos. It shares a common boundary with San Ildefonso, the second largest of the Tewa pueblos. The neighboring pueblos are rich in mineral resources and famous for their pottery. During the 1782 smallpox epidemic, more than 500 people died in a two-month period at those pueblos.

Nambe Pueblo was one of the Rio Grande pueblos that experienced a significant decline in population due to the executions brought on by witch mania during the 18th century. By 1900, the population had been reduced to 88 as a consequence of the tribe's elimination of members suspected of witchcraft.

The smallest and most acculturated of the six Tewa pueblos is Pojoaque Pueblo. From 1912 to 1934, no one lived on the pueblo. It was not until 1934 that members of the tribe began to return to the pueblo.

Tesuque Pueblo is the southernmost Tewa pueblo. During the 1680 Pueblo Revolt, two of its members figured prominently, warning the other pueblos of the date of the first strike. The first blood of the revolt was shed at Tesuque on August 9, 1680, with the killing of the Spaniard Cristobal de Herrera.

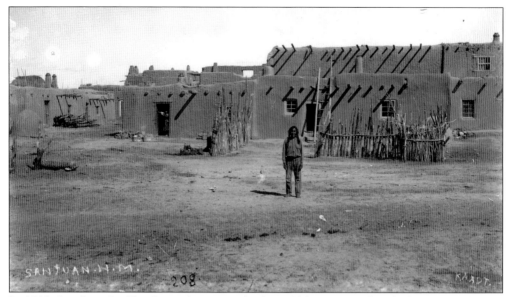

In 2005, San Juan Pueblo changed its name back to Ohkay Owingeh, which means "Place of Strong People" in Tewa. It was the pueblo's original name before the Spanish takeover in 1598. Juan de Oñate had christened the pueblo San Juan de los Cabelleros in honor of St. John the Baptist and his soldiers. After 407 years, the Pueblos decided to reclaim their identity. The pueblo is pictured here around 1889. (Photograph by Christian G. Kaadt, Palace of the Governors [NMHM/DCA], No. 0122424.)

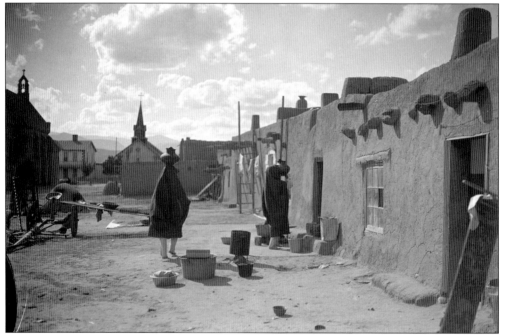

The San Juan Mission Church served as the Roman Catholic parish center for the neighboring Spanish communities during the 19th century. The church is on the left in this 1904 photograph, with Our Lady of Lourdes Chapel at the center of the pueblo. (Photograph by Edward S. Curtis, Palace of the Governors [NMHM/DCA], No. 144550.)

The Spanish colonists introduced many new crops to New Mexico, including wheat, which became the most important. The process of separating the grain from the chaff through a sieve, known as winnowing wheat, was quickly adopted by the Pueblos. Here, three women apply this process after the harvest in 1905. (Photograph by Edward S. Curtis, Palace of the Governors [NMHM/DCA], No. 144549.)

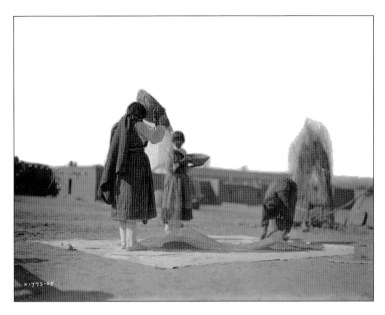

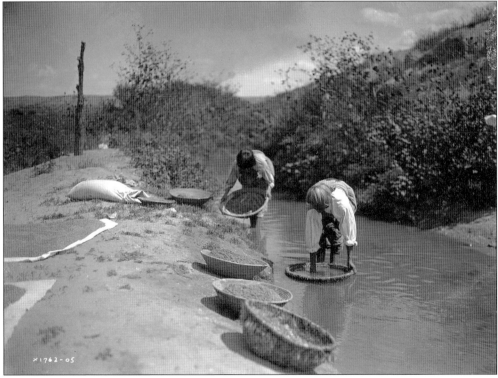

The cultivation of wheat soon rivaled corn, the original staple of the Pueblos, and surpassed it in trade, providing economic stability. This photograph from 1905 shows Ohkay Owingeh women washing wheat in the river. (Photograph by Edward S. Curtis, Palace of the Governors [NMHM/DCA], No. 031249.)

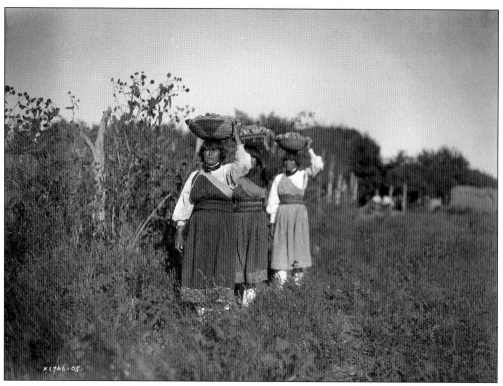

In addition to wheat, the Spaniards also introduced barley, chili, tomatoes, onions, peaches, apricots, apples, and melons to New Mexico. This photograph of the 1905 annual harvest at Ohkay Owingeh includes three women returning from the fields bringing vegetables to the pueblo. (Photograph by Edward S. Curtis, Palace of the Governors [NMHM/DCA], No. 089929.)

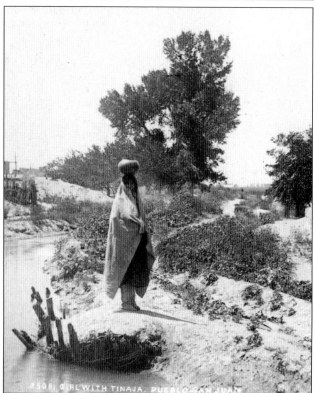

Ohkay Owingeh is located on the east and west banks of the Rio Grande. Like all Pueblo people, they consider water to be the most precious element of life in the high mountain desert of New Mexico. The job of hauling water to the pueblo was traditionally done by women, as seen in this c. 1875 photograph. (Photograph by William Henry Jackson, Palace of the Governors [NMHM/DCA], No. 049818.)

Of the domesticated animals brought by the Spaniards to New Mexico, the horse transformed the lives of the Pueblo Indians the most, providing them with the mobility to travel great distances in a single day. Ohkay Owingeh men are shown on horseback in this c. 1880 photograph. (Photograph by Bennet and Brown, Palace of the Governors [NMHM/DCA], No. 046201.)

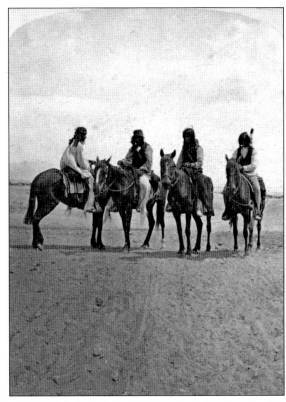

The introduction of the burro to the Pueblos provided them with a means to transport goods, and many of them also became domesticated pets. This c. 1875 photograph is of Diego, an Ohkay Owingeh boy, with his burro. (Photograph by William Henry Jackson, Palace of the Governors [NMHM/DCA], No. 054093.)

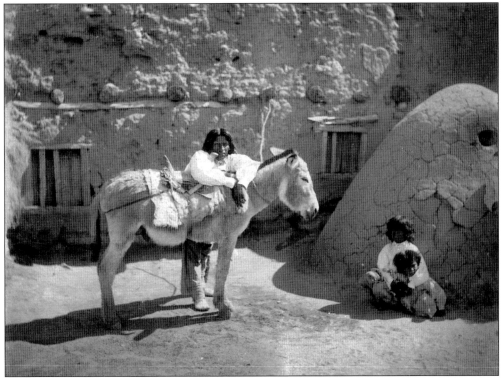

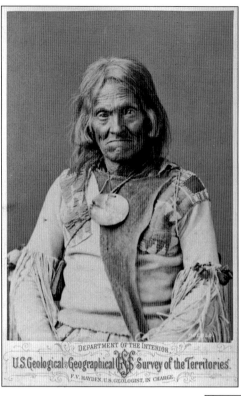

Pueblo elder Antonio Jose Atencio (Nan q Yaen, or "Swaying Aspen"), of Ohkay Owingeh, was photographed in Washington, DC, as part of the US Geological and Geographical Survey of the Territories. In this c. 1868 photograph, the tribal leader is wearing traditional clothing with a quilled, fringed buckskin shirt, fur mantle, and abalone-shell gorget collar. (Palace of the Governors [NMHM/DCA], No. 087539.)

This governor at Ohkay Owingeh strikes a pose indicative of the pueblo's name, the "Place of Strong People." The governor is wrapped in a traditional woolen blanket with the pueblo in the background of this c. 1879 photograph. (Photograph by John K. Hillers, Palace of the Governors [NMHM/DCA], No. 073900.)

The seeds of defiance toward the Spanish colonists that led to the Pueblo Revolt of 1680 began at Ohkay Owingeh with Po'pay, their leader and medicine man. The pose of these two men, photographed around 1889, illustrates the determination and resolve of the people. (Photograph by Christian G. Kaadt, Palace of the Governors [NMHM/DCA], No. 046090.)

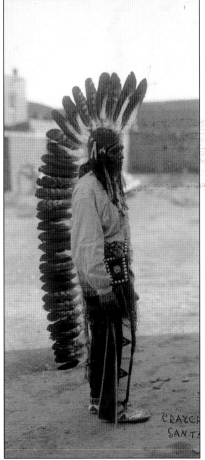

The Spaniards forced the Pueblo people to work as slaves and frequently burned their sacred objects and their ceremonial chambers known as *kivas* in order to discourage their traditional ceremonial dances. Forty-seven religious Pueblo leaders were falsely accused of witchcraft and flogged in Santa Fe in 1676. One of the men persecuted was Po'pay, who later led the Pueblo Revolt of 1680. An Ohkay Owingeh Pueblo man is seen here around 1905 after taking part in a ceremonial dance that endured despite the 17th-century Spanish oppression. (Photograph by Aaron B. Craycraft, Palace of the Governors [NMHM/DCA], No. 046018.)

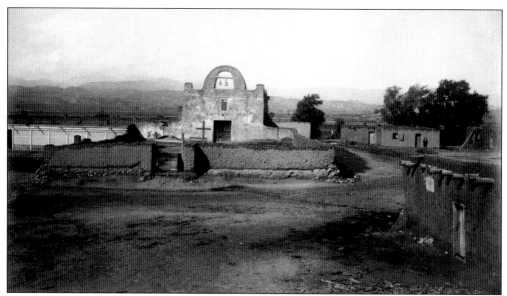

This 1881 photograph shows the Mission Church of San Juan at Ohkay Owingeh, which was originally named for an apostle but later renamed for an army. In 1598, the Spanish explorer Juan de Oñate named the church in honor of St. John the Baptist. Shortly thereafter, the soldier/scribe Gaspar Perez de Villagra, who chronicled the 1598 settlement in New Mexico, renamed it San Juan de los Caballeros ("St. John of the Warrior Knights"). The mission was one of the first churches destroyed during the Pueblo Revolt of 1680. It went through several reconstructions and reincarnations from the middle of the 17th century through the latter part of the 19th century. (Photograph by William H. Rau, Palace of the Governors [NMHM/DCA], No. 100000.)

Located on the west bank of the Rio Grande, the Pueblo of Santa Clara is the third largest Tewa pueblo in northern New Mexico. It is considered one of the wealthiest pueblos because of its land, which is rich in pumice and other mineral resources. This is a c. 1905 photograph of a lone woman at Santa Clara Pueblo. (Photograph by Edward S. Curtis, Palace of the Governors [NMHM/DCA], No. 144523.)

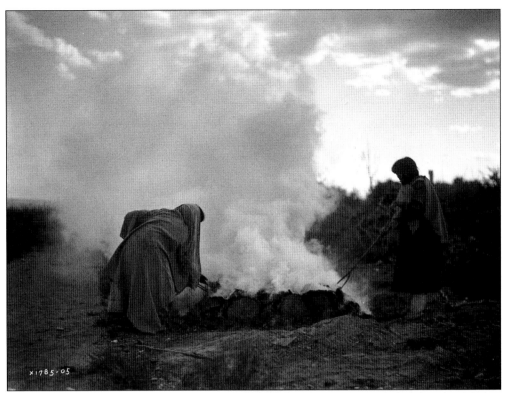

Photographed around 1905, two women from Santa Clara Pueblo prepare their pottery kiln. In the ancient tradition of their ancestors, the pit is heated with cow and horse dung. (Photograph by Edward S. Curtis, Palace of the Governors [NMHM/DCA], No. 031940.)

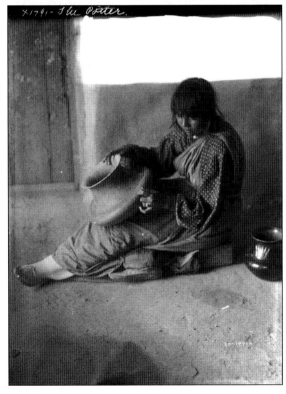

At the turn of the 20th century, shards of Neolithic pottery were discovered in the ruins of northern New Mexico, and the shiny black pottery was reintroduced to the pueblos. This woman from Santa Clara Pueblo polishes one of her pots around 1905. (Photograph by Edward S. Curtis, Palace of the Governors [NMHM/DCA], No. 143722.)

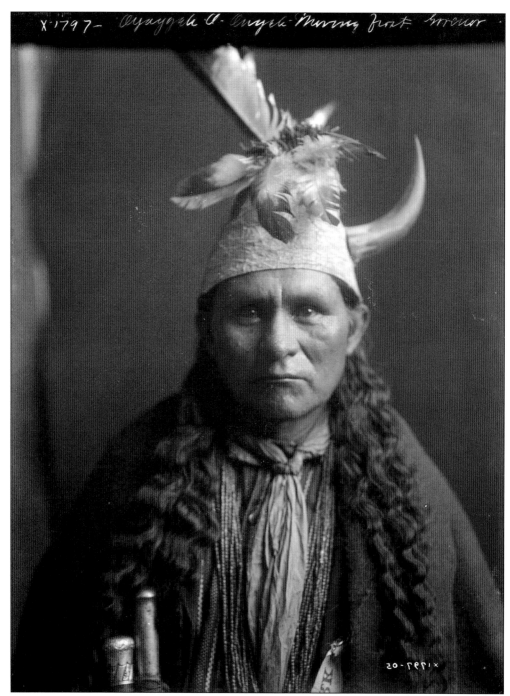

Oyaygeh-o-onyeh, which means "Moving Frost" in Tewa, was a governor of Santa Clara Pueblo around 1905. The pueblo remains in the same location that it inhabited prior to the Pueblo Revolt of 1680. (Photograph by Edward S. Curtis, Palace of the Governors [NMHM/DCA], No. 143717.)

Santa Clara was made a seat of the Catholic Church with a mission, church, and monastery erected between 1622 and 1629. The ancestors of Oyay Sougwi ("Frost Design" in Tewa), who is pictured here in 1905, helped to build and maintain the Catholic compound. (Photograph by Edward S. Curtis, Palace of the Governors [NMHM/DCA], No. 143721.)

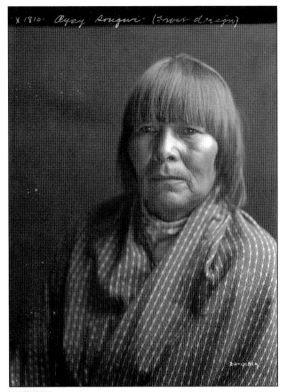

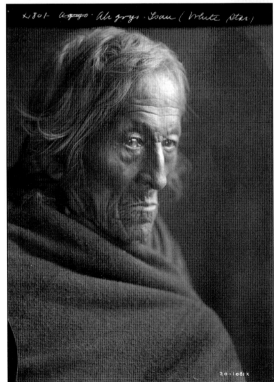

The eyes of Agoya Tsan ("White Star"), an elderly Santa Clara man, reflect a life of wisdom as he poses for a photograph in 1905. Prior to the Spanish colonial era, his ancestors cultivated corn, beans, squash, and cotton. (Photograph by Edward S. Curtis, Palace of the Governors [NMHM/DCA], No. 143720.)

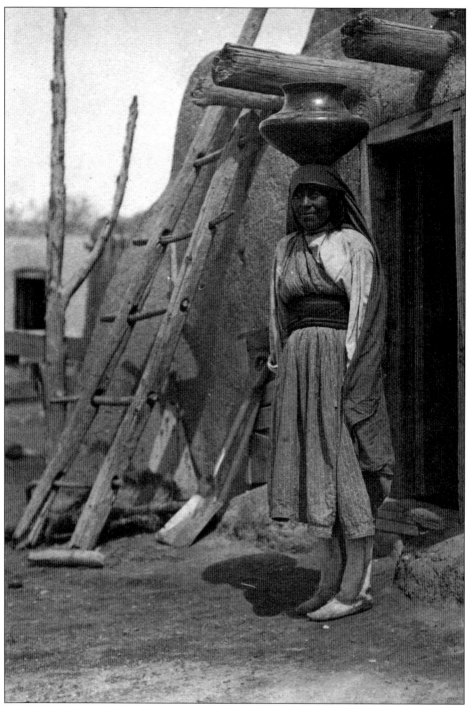

During prehistoric times, the people of Santa Clara devised an irrigation system that allowed them to divert water from the Rio Grande to their fields at lower elevations. The new system freed the pueblo from being dependent on rainfall for crops. This water carrier photographed in 1910 was identified as the mother of Molly and Frances Chaverria. (Photograph by Carter H. Harrison, Palace of the Governors [NMHM/DCA], No. 042726.)

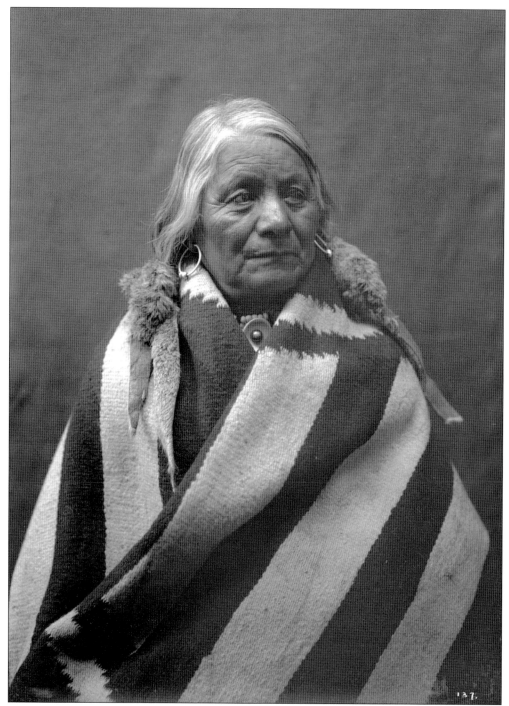

Santiago Naranjo traveled to Washington, DC, in 1923 as part of a contingent of Pueblo leaders who opposed the Bursum Bill. This bill would have deprived the Pueblos of their land and water rights in favor of non-Pueblo people living near the pueblos. Naranjo is shown here at Santa Clara Pueblo around 1910. (Photograph by Jesse Nusbaum, Palace of the Governors [NMHM/ DCA], No. 061707.)

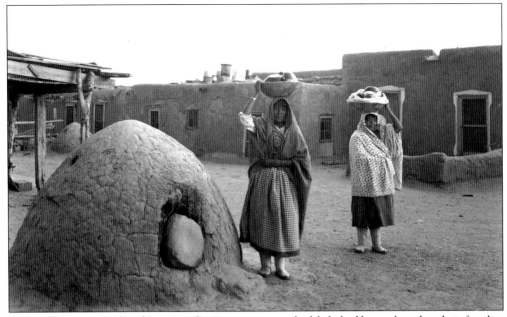

Pablita Chaverria (left) and Faustina Gutierrez transport freshly baked horno bread to their families at Santa Clara Pueblo around 1920. A boulder was used as a door to the horno to contain heat in the oven. (Photograph Palace of the Governors [NMHM/DCA], No. 004151.)

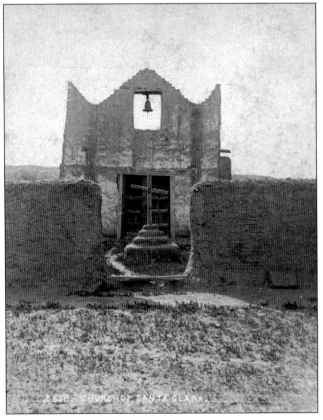

This c. 1880 photograph of the Mission Church of St. Claire at Santa Clara Pueblo provides a glimpse of the structure as it was built in 1758. Fray Mariano Rodriguez de Torre constructed the church from the rubble of the pre–Pueblo Revolt church. The church at Santa Clara has gone through many renovations in the last three centuries, including the addition of a pitched roof in 1905. (Photograph by William Henry Jackson, Palace of the Governors [NMHM/DCA], No. 154616.)

After the Pueblo Revolt, members of San Ildefonso fled for their safety and fortified themselves in the mountains atop the Black Mesa until 1694. A San Ildefonso governor is seen here around 1884 at the pueblo. (Photograph by Dana B. Chase, Palace of the Governors [NMHM/DCA], No. 057005.)

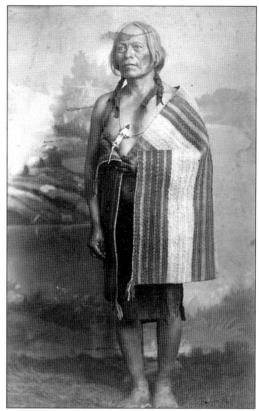

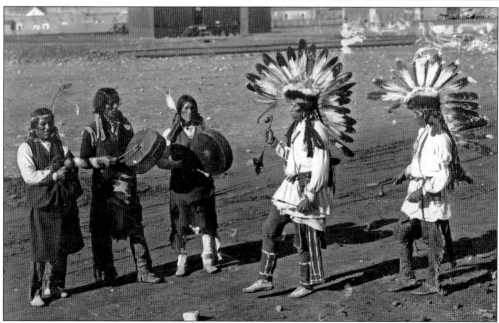

Ceremonial dances take place during the feast day for San Ildefonso each year on January 23. The drummers lead the dancers at this San Ildefonso Pueblo event in 1884. (Photograph by Dana B. Chase, Palace of the Governors [NMHM/DCA], No. 042197.)

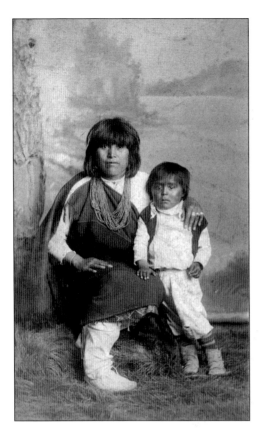

The Spanish introduced diseases unknown to the Pueblos, including smallpox, measles, malaria, typhus, typhoid, scarlet fever, and chickenpox. This c. 1884 photograph shows a mother and child at San Ildlefonso who most likely had family members who died from these European diseases. (Photograph by Dana B. Chase, Palace of the Governors [NMHM/DCA], No. 057003.)

Two San Ildefonso Pueblo men pose for a c. 1885 photograph. During pre-contact times, their ancestors cultivated the land using wooden shovels, hoes, and stone axes. (Photograph by Dana B. Chase, Palace of the Governors [NMHM/DCA], No. 057002.)

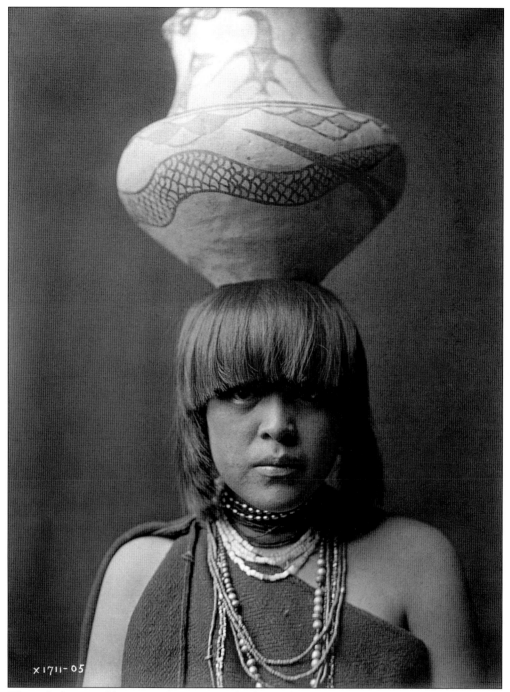

X1711-05

The prehistoric pueblo irrigation system involved considerable mechanical ingenuity that brought water closer to the communities. Povi Tamu ("Sun Flower") is pictured in 1905 with a traditional water jar that she used to bring water to her family. (Photograph by Edward S. Curtis, Palace of the Governors [NMHM/DCA], No. 143724.)

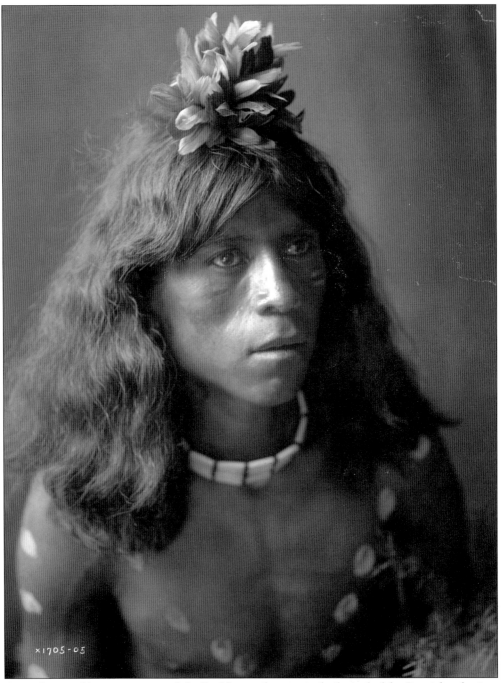

Agriculture and hunting sustained the Pueblo people prior to the arrival of the Spanish colonists. Povi Yamo ("Falling Flowers") was photographed with a plume of parrot feathers at San Ildefonso Pueblo around 1905. (Photograph by Edward S. Curtis, Palace of the Governors [NMHM/DCA], No. 143729.)

Yahn Tsideh ("Willow Bird"), a young man from San Ildefonso Pueblo, was photographed in 1905 after a day of hunting. At an early age, boys would accompany the men to learn to hunt deer and buffalo for the pueblo. (Photograph by Edward S. Curtis, Palace of the Governors [NMHM/DCA], No. 143726.)

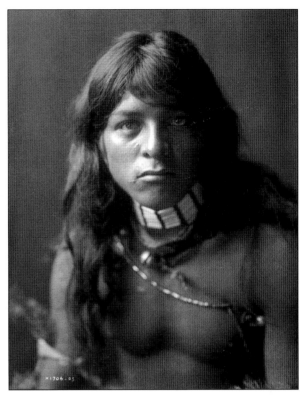

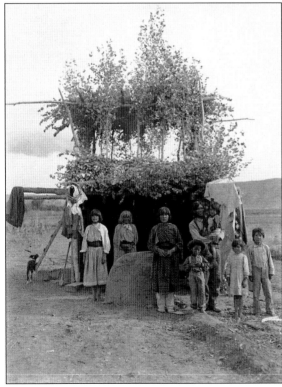

During the summer, Pueblo families sought relief from the heat along the Rio Grande. Juan Gonzales and his family are pictured in their summerhouse in 1908. (Photograph by Jesse Nusbaum, Palace of the Governors [NMHM/DCA], No. 061771.)

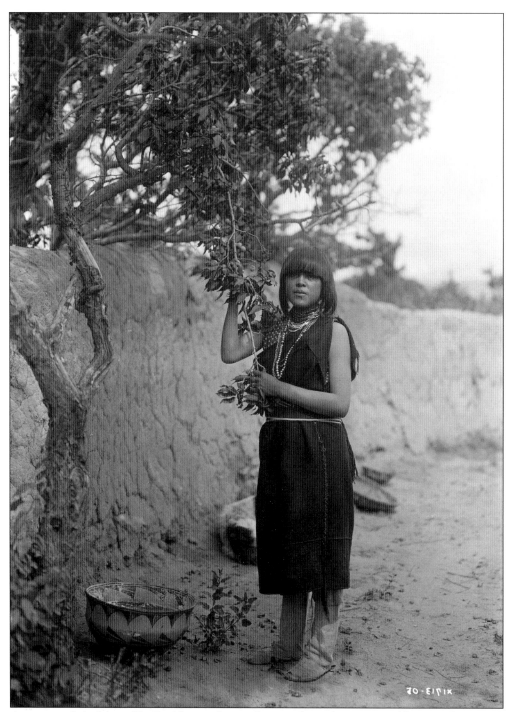

A common belief shared by Pueblo people was that anything that grows wild cannot be owned, but should rather be shared with everyone. This included plum and berry bushes that grew along the banks of the river, as well as asparagus, amaranth, basil, and mint. Here, Santana Montoya Vigil picks fruit at San Ildefonso Pueblo around 1905. (Photograph by Edward S. Curtis, Palace of the Governors [NMHM/DCA], No. 143723.)

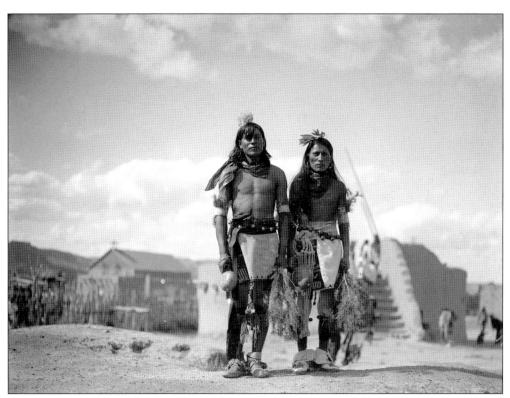

Julian Martinez (right) is pictured in this c. 1905 photograph of San Ildefonso Pueblo dancers. Typically, ceremonial dances were performed in front of the kiva, like the one that can be seen behind these dancers. (Photograph by Edward S. Curtis, Palace of the Governors [NMHM/DCA], No. 143732.)

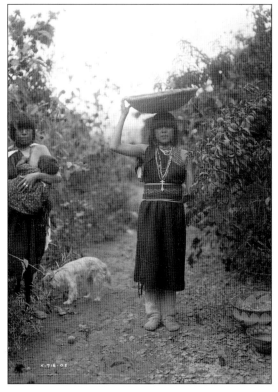

During the harvest, all members of the family pitched in to collect enough food to sustain them through the winter. These two women, one nursing a baby, work the fields with their dog by their side at San Ildefonso Pueblo around 1905. (Photograph by Edward S. Curtis, Palace of the Governors [NMHM/DCA], No. 144538.)

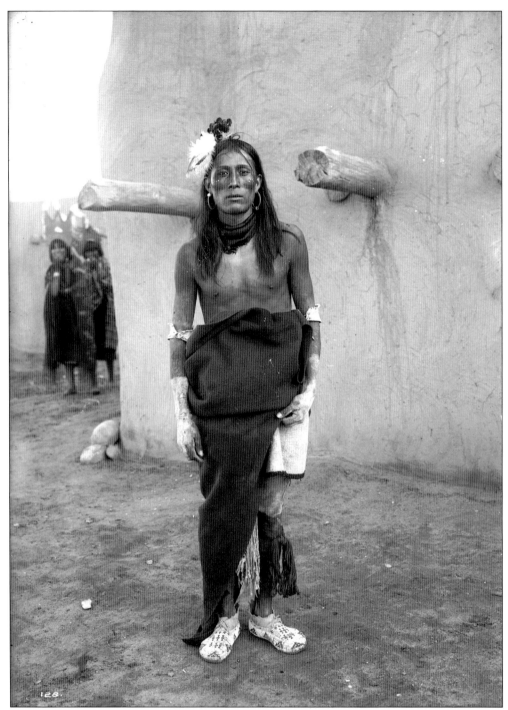

Florentine Martinez, the brother of Julian Martinez, poses for a photograph after taking part in a ceremonial dance in 1908. Entire families participated in these dances and taught future generations the importance of keeping traditions alive. Today, photography of ceremonial dances is strictly prohibited. (Photograph by Jesse Nusbaum, Palace of the Governors [NMHM/DCA], No. 061769.)

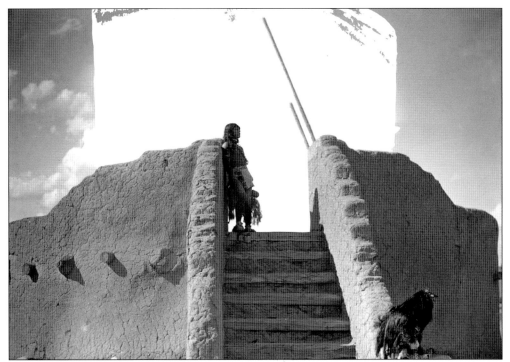

A man rests between dances in the entrance to the kiva at San Ildefonso Pueblo around 1905. All of the Pueblos have Catholic churches in their community, but the kiva serves as the nexus for their spiritual beliefs. (Photograph by Edward S. Curtis, Palace of the Governors [NMHM/DCA], No. 143705.)

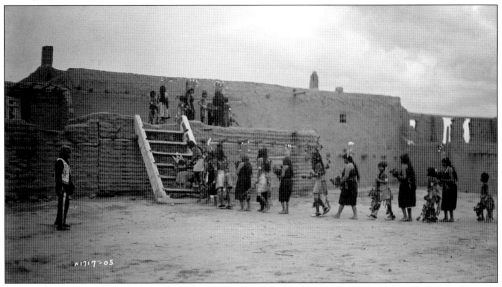

San Ildefonso Pueblo was the least receptive to Christianity. Not until the Catholic Church allowed the Pueblos to integrate some of their own ceremonies during the 19th century did the Pueblo people begin to adopt the new religious teachings. Here, pueblo members retire to the kiva around 1905 following a sacred ceremony. (Photograph by Edward S. Curtis, Palace of the Governors [NMHM/DCA], No. 143707.)

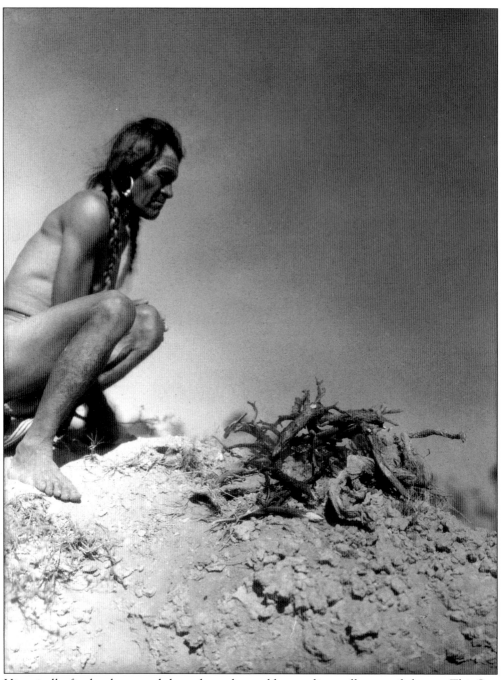

Historically, fire has been used throughout the world to eradicate all types of plagues. This San Ildefonso man is well aware of the curative elements of fire as he tends to the flames on the ridge of the pueblo in 1925. (Photograph by Edward S. Curtis, Palace of the Governors [NMHM/DCA], No. 160542.)

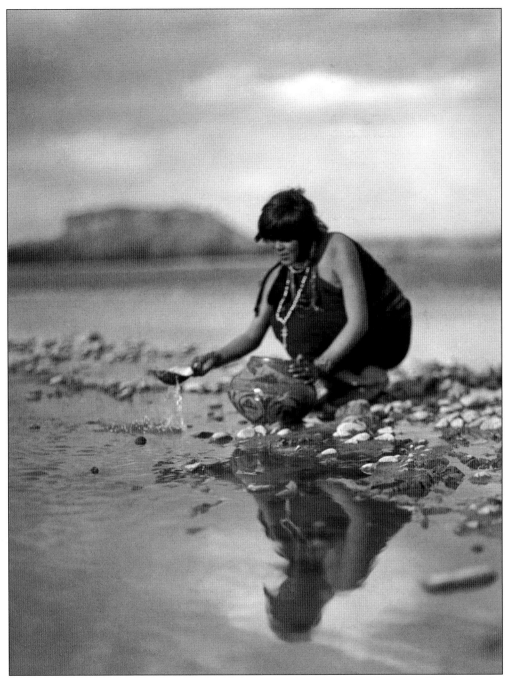

In 1903, the ethnographer Edward S. Curtis came to New Mexico to document Pueblo people. This image, taken in the early morning as a woman collects water at the river, was most likely one of his first photographs. The mesa at San Ildefonso is in the background. (Photograph by Edward S. Curtis, Palace of the Governors [NMHM/DCA], No. 144547.)

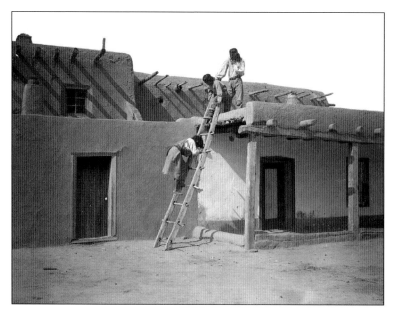

Considered one of the wealthier pueblos, the people of San Ildefonso often lived in larger quarters than some of their neighbors farther north. This woman descends from her multi-storied house in 1925. (Photograph by Edward S. Curtis, Palace of the Governors [NMHM/DCA], No. 031968.)

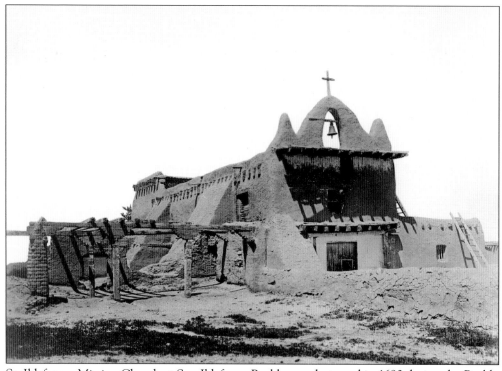

St. Ildefonsus Mission Church at San Ildefonso Pueblo was destroyed in 1680 during the Pueblo Revolt. By 1701, reconstruction of the church began under the guidance of Fray Juan de Tagle; it was dedicated in 1711. Through the next century, the church underwent several reincarnations. This 1899 photograph was taken prior to the construction of a new American-style church that was capped with a tin roof. (Photograph by Adam C. Vroman, Palace of the Governors [NMHM/DCA], No. 164157.)

Nambe Pueblo, like the neighboring Pojoaque Pueblo, has been entrenched with Spanish culture since 1776. Members of this Nambe family, photographed in 1914, were likely among the many Nambe Pueblo people and other Native American groups who were relocated during the Reorganization Act of 1934. During the "Indian New Deal," the people of Nambe were moved to California under the premise that they would assimilate into American society. After two decades, many of them decided to move back to their agrarian way of life, which had been kept intact by the 50 remaining families who had stayed. (Photograph by Waldo Twitchell, Palace of the Governors [NMHM/DCA], No. 002995.)

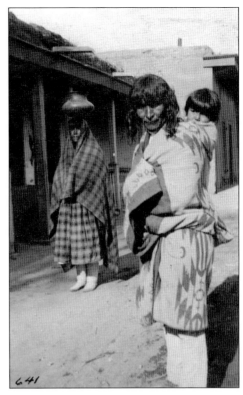

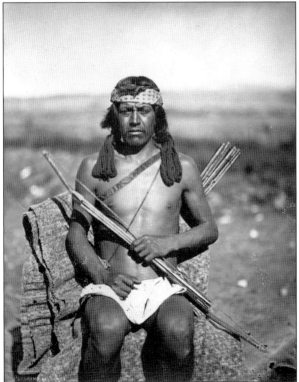

This c. 1879 photograph shows a Nambe Pueblo warrior named Potshuno in Tewa. He also went by the Spanish name Jose Antonio Vigil. In 1776, Nambe Pueblo consisted of approximately 50 families, but the encroachment on pueblo lands by local Hispanos and intermarriage with outsiders threatened the Pueblo people's cultural identity. (Photograph by John K. Hillers, Palace of the Governors [NMHM/DCA], No. 055217.)

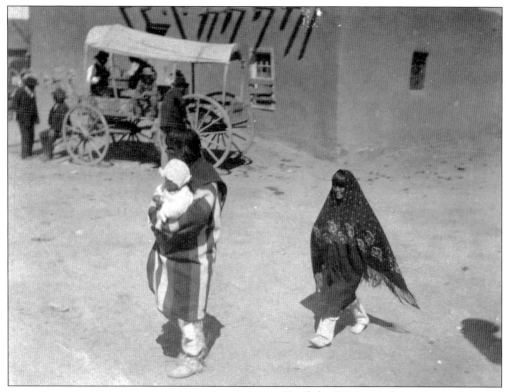

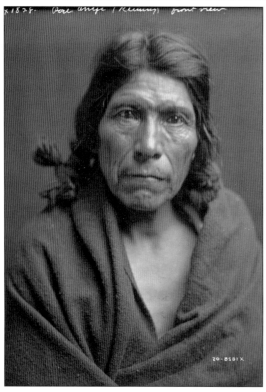

Until the 1860s, witch mania consumed Nambe Pueblo. From a population of approximately 350, it dwindled to around 50 people as Pueblo authorities executed people suspected of practicing the "black arts." Above, a Nambe man carries his child with his wife following behind in a photograph taken in 1905. At left, Pose Anyi, Tewa for "raining," poses at Nambe Pueblo in 1905. (Above, Palace of the Governors [NMHM/DCA], No. 065318; left photograph by Edward S. Curtis, Palace of the Governors [NMHM/DCA], No. 14709.)

Cohat Sougar was photographed in 1905. The young Nambe girl wears a head covering typically worn in Spanish villages through the mid-20th century. (Photograph by Edward S. Curtis, Palace of the Governors [NMHM/DCA], No. 143743.)

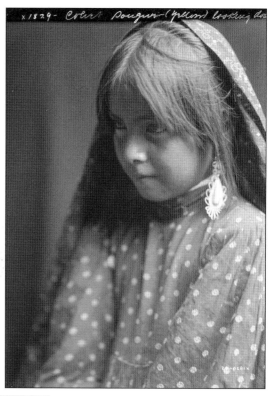

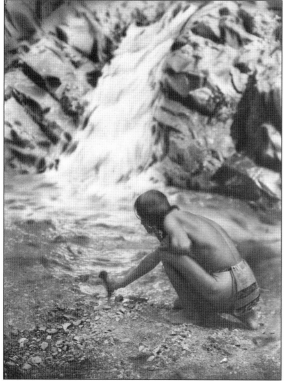

The Nambe Pueblo waterfall situated at the base of the Sangre de Cristo Mountains provided irrigation to neighboring villages. This photograph, taken around 1915, shows a Nambe Pueblo man with an offering at the waterfall. Water and all earth elements are central to the beliefs of the Pueblo people. (Photograph by Edward S. Curtis, Palace of the Governors [NMHM/DCA], No. 160546.)

49

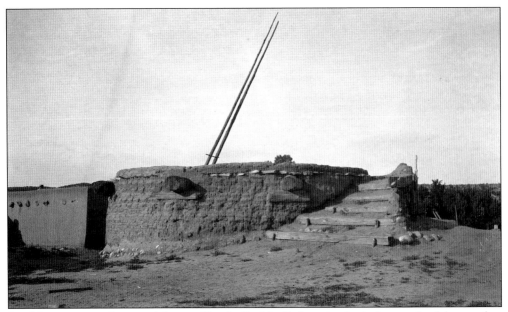

In addition to scant historical data on Nambe Pueblo, little archeological research of the area has been completed. This c. 1915 photograph of the kiva at Nambe Pueblo shows one of the few buildings documented. (Photograph courtesy, Palace of the Governors [NMHM/DCA], No. 03044.)

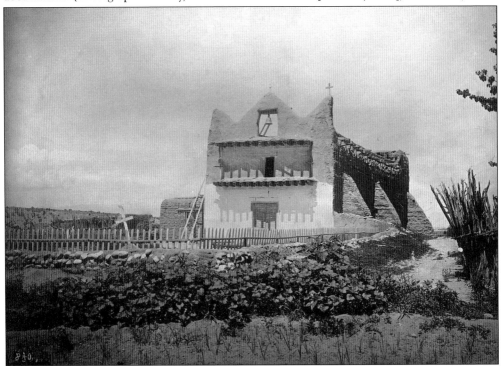

This 1899 photograph shows the San Francisco Mission Church of Nambe Pueblo, which was built in the early 18th century and dedicated in 1725. Fray Diego Martinez helped to restore the church during his ministry from 1804 to 1809. (Photograph by Adam C. Vroman, Palace of the Governors [NMHM/DCA], No. 012356.)

Pojoaque Pueblo is the smallest of the six Tewa pueblos. This 1905 photograph of the pueblo was taken when it was virtually abandoned. From 1912 through 1934, Pojoaque Pueblo was not occupied, but tribal members lived in some of the neighboring pueblos or in the immediate vicinity. Antonio Jose Tapia is credited with the resettlement of the pueblo. After living and working in Colorado in 1912, he returned in the 1930s and worked to bring other people back to live on their native land. (Photograph by Edward S. Curtis, Palace of the Governors [NMHM/DCA], No. 14397.)

A public secondary school was opened by the Santa Fe County district at Pojoaque Pueblo after its resettlement in the 1930s. These Pueblo children stand next to an American flag wearing Western clothing with a horno in the background. (Photograph by Mary E. Dissette, Palace of the Governors [NMHM/DCA], No. 003357.)

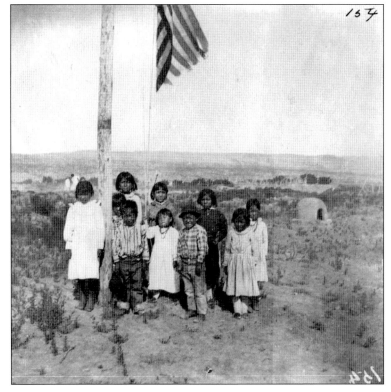

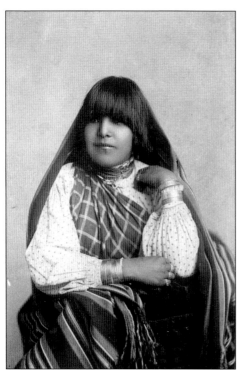

Pojaoque Pueblo members' participation in ceremonial dances at Nambe and Santa Clara helped them maintain their cultural identity since they were engulfed by Spanish Americans. A Pojoaque Pueblo girl is shown in this c. 1884 photograph wearing traditional clothing. The Spanish head scarf is indicative of the encroaching influence of the traditions of the Hispanic families who lived in the immediate area. (Photograph by Dana B. Chase, Palace of the Governors [NMHM/DCA], No. 046151.)

In 1773, the Mission Church of Nuestra Señora de Guadalupe at Pojoaque Pueblo was rebuilt by Fray Jose Llanos. In 1707, after the Pueblo Revolt, Spanish officials revived the Pueblo of Pojoaque, bringing displaced Tewa Indians and people from the pueblo of Pecos. This 1899 photograph shows the ruins of that church. (Photograph by Adam C. Vroman, Palace of the Governors [NMHM/DCA], No. 013894.)

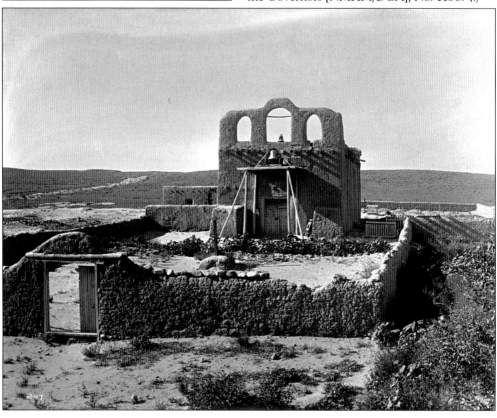

Tesuque Pueblo made distinguished contributions during the Pueblo Revolt. Two of its men, Nicolas Catua and Pedro Omtua, were sent as runners to the other pueblos to alert the chiefs of plans for the uprising. It was at Tesuque Pueblo that the first blood of the revolt was shed on August 9, 1680, with the killing of a Spaniard, Cristobal de Herrera. The men featured in this 1880 photograph at Tesuque Pueblo show the same determination as the proud warriors who took part in the Pueblo Revolt. (Photograph by Bennet and Brown, Palace of the Governors [NMHM/DCA], No. 077661.)

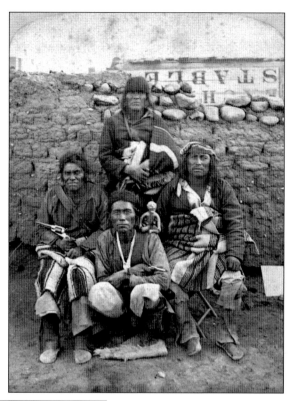

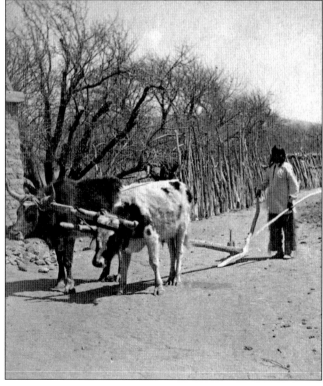

Oxen were introduced to New Mexico by Spanish colonists in 1598. This c. 1880 photograph at Tesuque Pueblo shows a man taking oxen to the fields. (Photograph by Bennet and Brown, Palace of the Governors [NMHM/DCA], No. 055005.)

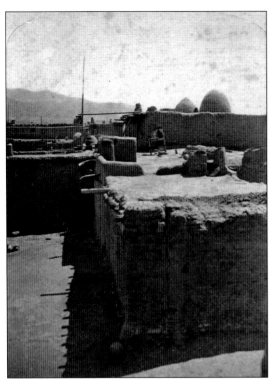

The horno originated in the Middle East and was introduced to Spain by the Moors. With the advent of the horno, the Pueblos were able to insulate their food as it was being prepared, rather than cooking on an open fire. This c. 1880 photograph shows two hornos built on a rooftop at Tesuque Pueblo. (Photograph by Bennet and Brown, Palace of the Governors [NMHM/DCA], No. 086850.)

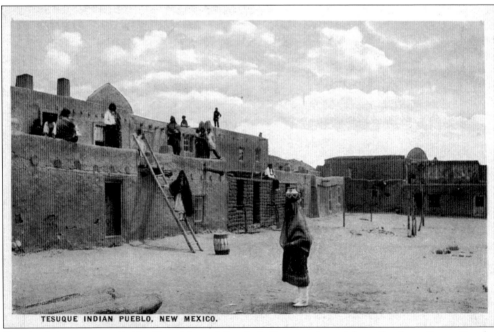

TESUQUE INDIAN PUEBLO, NEW MEXICO.

Despite being surrounded by Spanish and Anglo influences just eight miles from Santa Fe, the Tesuque Pueblo has remained one of the most conservative and traditional pueblos. This c. 1910 photograph was made into a postcard to promote tourism, which became a major source of income for all of New Mexico's pueblos since the start of the 20th century. (Photograph by Aaron B. Craycraft, Palace of the Governors [NMHM/DCA], No. 089882.)

With its close proximity to Santa Fe, the pueblo children were discouraged from speaking their native language at the public schools run by the district, which resulted in the decline of the Tewa language. A group of Tesuque Pueblo children stand in front of a fence to have their picture taken around 1880. (Photograph by Bennet and Brown, Palace of the Governors [NMHM/DCA], No. 037443.)

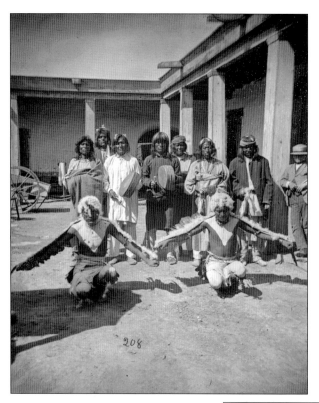

During the latter part of the 19th century, it was not uncommon for spectators to come to the pueblo dances. In this c. 1880 photograph, Tesuque Pueblo men watch two eagle dancers while an Anglo boy leans on a wooden beam at right. (Photograph by Ben Wittick, Palace of the Governors [NMHM/DCA], No. 015580.)

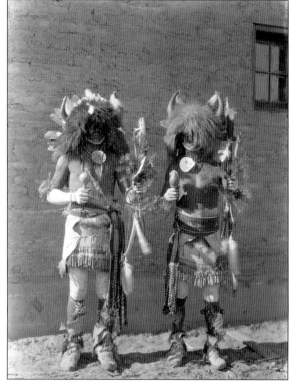

These two Pueblo men were photographed in 1925 as they prepared for the buffalo dance. Pueblo people regularly hunt bison during the winter. The buffalo dance is usually performed prior to the hunting season. As more people moved to the area the Pueblos grew accustomed to outsiders taking photographs, but only allowed them to photograph certain ceremonial dances. (Photograph by Edward S. Curtis, Palace of the Governors [NMHM/DCA], No. 144657.)

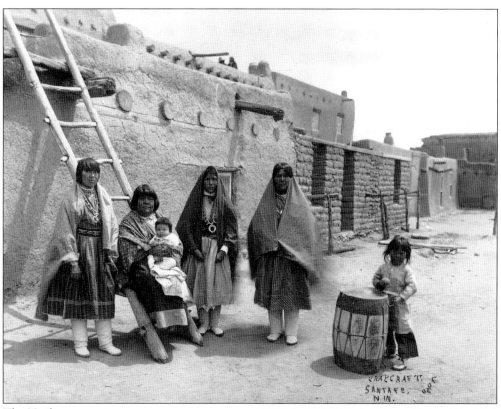

The Vigil surname is common at Tesuque Pueblo. This c. 1905 photograph shows the Vigil family women and children. (Photograph by Aaron B. Craycraft, Palace of the Governors [NMHM/DCA], No. 004769.)

Manuel Vigil is pictured in a doorway at Tesuque Pueblo around 1925. The adobe entrance is held in place by a *viga* (wooden beam) above that supports the structure. (Photograph by T. Harmon Parkhurst, Palace of the Governors [NMHM/DCA], No. 144712.)

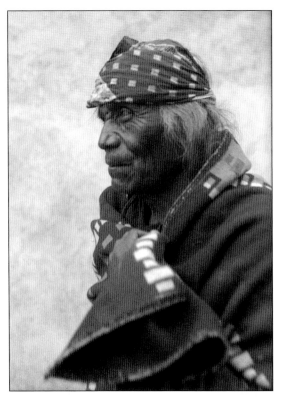

Tiofilo Romero is pictured at Tesuque Pueblo in 1912. The same year this photograph was taken, New Mexico became the 47th state of the union. After 250 years living under the governments of Spain and Mexico, the Pueblo people would once again have to adapt to a new form of government. (Photograph by Jesse Nusbaum, Palace of the Governors [NMHM/DCA], No. 061718.)

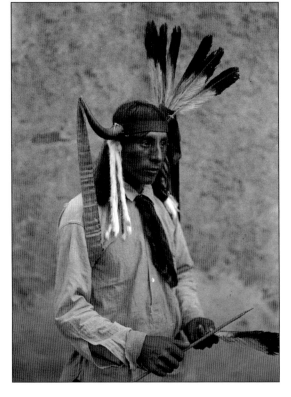

Candido Herrera prepares for a ceremonial dance at Tesuque Pueblo in 1912. The animal dance features a one-horned buffalo and feather headdress. During the dance, the participants use a particular gait or movement to represent buffalo, antelope, and deer. (Photograph by Jesse Nusbaum, Palace of the Governors [NMHM/DCA], No. 061793.)

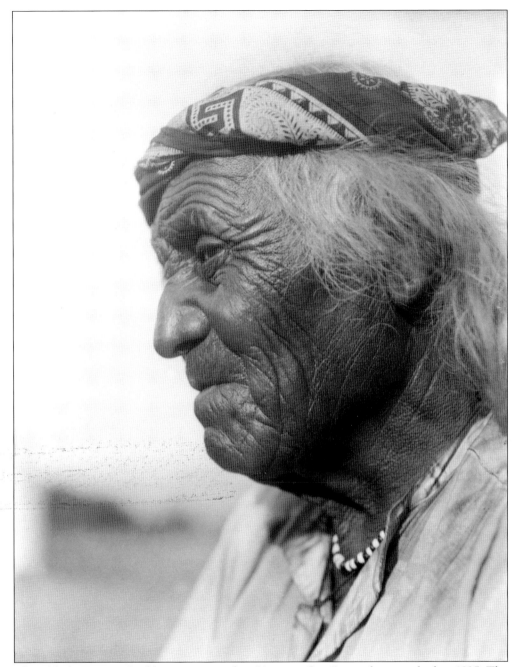

This elderly Tesuque Pueblo man, revered as "Ancient One," was photographed in 1925. The elderly are esteemed for carrying on the oral traditions of the pueblos in New Mexico, passing their history and culture from generation to generation. (Photograph by Edward S. Curtis, Palace of the Governors [NMHM/DCA], No. 144712.)

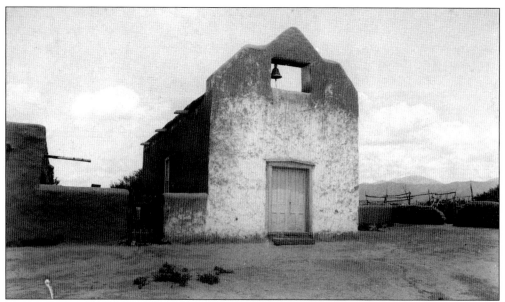

The Mission Church of San Diego at Tesuque Pueblo was destroyed after the Pueblo Revolt and rebuilt in 1695 under the supervision of Fray Jose Diaz. In 1745, a new church was built at the pueblo supervised by Fray Francisco Gonzalez. By the 1870s, the church fell into ruin and shuttered its doors. This c. 1884 photograph shows the renovations that were done in 1881, when the church reopened. (Photograph by Dan b. Chase, Palace of the Governors [NMHM/DCA], No. 004869.)

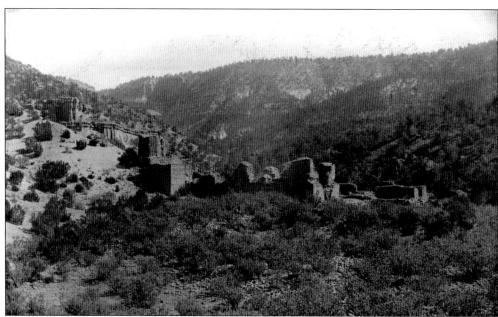

Jemez and Tesuque Pueblos share the same patron saint. The San Diego Mission Church is pictured in ruins at Jemez Pueblo around 1880. The first church at the pueblo was built between 1724 and 1726. By 1776, a new church was built 150 yards from the original site. (Photograph by Ben Wittick, Palace of the Governors [NMHM/DCA], No. 015591.)

Three

TOWA PUEBLOS

Jemez Pueblo is located on the east bank of the Jemez River 25 miles northwest of Bernalillo. More than any of the other pueblos, its people are considered the highlanders because of their location in the Jemez Mountains. They are the only Towa-speaking pueblo left in New Mexico. It is believed that their present dialect grew out of a combination of the original dialects spoken at the extinct Pueblo of Pecos and that of Jemez, after the surviving members of Pecos joined Jemez Pueblo in 1838.

The Pueblo of Pecos was located about 18 miles southeast of Santa Fe. Primarily a farming community, the population of Pecos had as many as 2,000 inhabitants when Gaspar Castaño de Sosa entered the region in 1590–1591. Separated from other pueblos along the Rio Grande, it was unable to protect itself from attacks from the Comanche Indians. During the aftermath of the constant attacks and the epidemic of smallpox, the Pueblo of Pecos continued to dwindle. By 1838, its people decided to make a new home with Jemez, who spoke their language. The Pueblo of Jemez was sympathetic to their plight and welcomed the Pecos refugees.

Jemez Pueblo sparked the first retaliation against the Spanish in 1649, and was brutally punished. The pueblo was one of the first to experience the Recopilacion de Leyes Reynos de las Indias. Devised by the Spanish missionaries, this was an imposed law that provided land grants to Spanish people adjacent to Pueblo property. The law included the clause of *repartimiento*, the right to employ Pueblo Indians living near the appropriated parcels of land to the *encomendero* (landowner). These grants, which became known as *encomiendas*, caused a lot of tension for Jemez and the other neighboring communities. Not only were they forced to work for the Spaniards, they also had to provide food that they had stored for the winter to help support the mission church communities. Jemez Pueblo actively participated in the Pueblo Revolt of 1680.

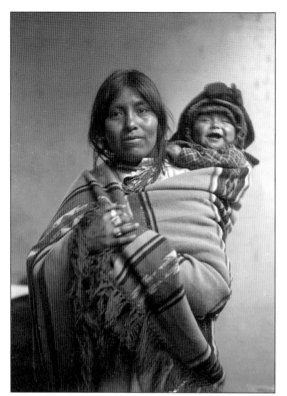

Jemez is the only pueblo in New Mexico to speak Towa, one of the Tanoan languages, which are part of at least seven distinct aboriginal linguistic families in the Southwest. This photograph of a woman and her child, possibly descendants of Pecos Pueblo, was taken in 1914. (Photograph by Jesse Nusbaum, Palace of the Governors [NMHM/DCA], No. 016712.)

Jose Victoriano Martin, the governor of Jemez Pueblo, poses with his wife, Maria Rey, for a c. 1879 photograph. Their parents spoke a form of the Towa language that was native to Jemez Pueblo prior to its integration with the Towa spoken at the Pecos Pueblo. In 1838, the survivors from Pecos joined Jemez Pueblo after their pueblo dwindled in population due to the deaths from disease and attacks from marauding tribes. (Photograph by John K. Hillers, Palace of the Governors [NMHM/DCA], No. 073899.)

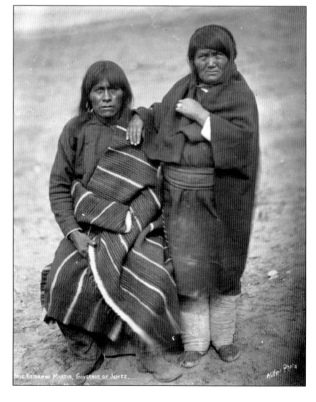

From 1902 until his death in 1919, Augustine Pecos was the last survivor of the 17 people who emigrated from the Pecos Pueblo to Jemez Pueblo in 1838. Barely a teenager, around the age of 12 or 15, Pecos joined the small group who fled their desolate pueblo to become part of Jemez, the only other pueblo in New Mexico whose inhabitants spoke their native language of Towa. In 1904, Pecos provided the names of the diaspora, which proved to be invaluable to the history of New Mexico pueblos. He is pictured here in 1914. (Photograph by Jesse Nusbaum, Palace of the Governors [NMHM/DCA], No. 016706.)

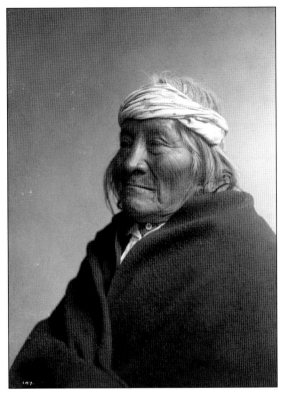

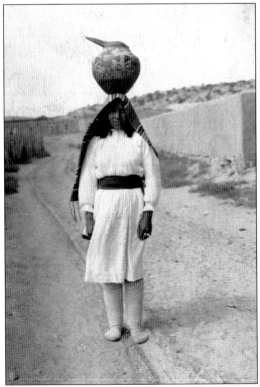

Jemez Pueblo is located on the east bank, separating it from other pueblos along the Rio Grande. Building their pueblo on a mesa in the Jemez Mountains, they are considered the "highlanders," close to the hot springs named for the pueblo. The pueblo's access to different mineral waters from the hot springs is evident in this c. 1912 photograph. (Palace of the Governors [NMHM/DCA], No. 002780.)

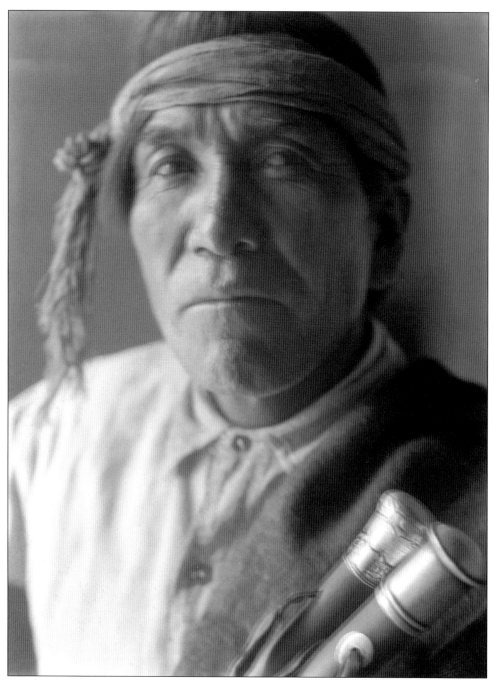

With the arrival of the Spanish government in New Mexico, each of the 19 pueblos was presented with a silver-crowned cane to signify leadership and sovereignty. A Christian cross was engraved on the head of the cane, indicating that it had the blessing of the Catholic Church. Later, the US government provided each pueblo with a similar honor known as Lincoln canes. Tsola, "chipmunk" in Towa, was the governor of Jemez Pueblo in 1925. He is seen holding two of the silver-headed canes that symbolize Pueblo authority. (Photograph by Edward S. Curtis, Palace of the Governors [NMHM/DCA], No. 144727.)

Hope, a village elder, was photographed at Jemez Pueblo in 1925. Through the middle of the 20th century, Pueblo men wore headbands as part of their daily attire. (Photograph by Edward S. Curtis, Palace of the Governors [NMHM/DCA], No. 144659.)

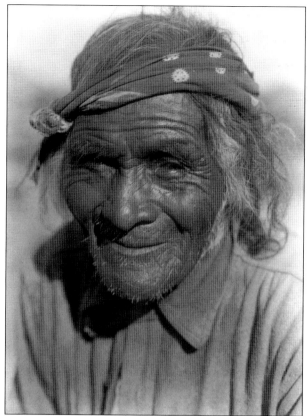

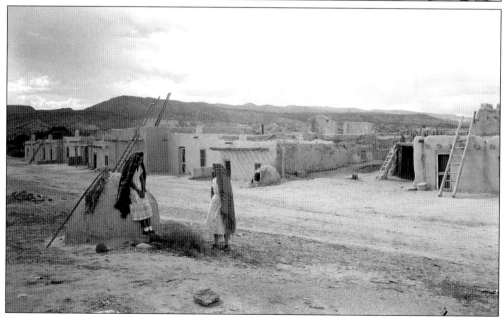

A woman rests on top of a horno at Jemez Pueblo while talking with a friend. The Jemez Springs are located in the mountains in the background of this c. 1920 photograph. (Photograph by T. Harmon Parkhurst, Palace of the Governors [NMHM/DCA], No. 002804.)

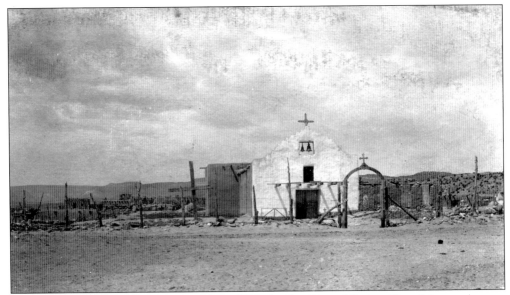

Since the establishment of Jemez Pueblo in 1706, the San Diego Mission Church has undergone many reconstruction phases beginning in 1724 and continuing through the mid-20th century. This photograph at Jemez Pueblo was taken a year after a new church was built in 1919. That church was destroyed by fire in 1937 and rebuilt shortly thereafter. (Palace of the Governors [NMHM/DCA], No. 002767.)

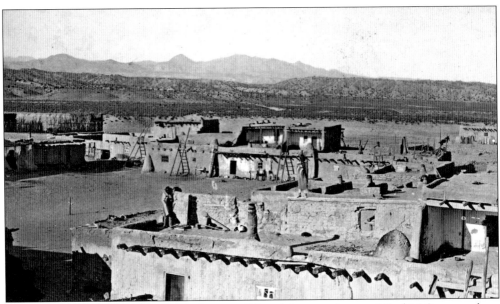

The people of Cochiti Pueblo fled to the top of Horn Mesa, southwest of Cochiti Canyon, along with others from Santo Domingo and Taos Pueblos during the Pueblo Revolt in 1680. The Jemez Mountains are in the background of this view of Cochiti Pueblo taken around 1881. (Photograph by George C. Bennett, Palace of the Governors [NMHM/DCA], No. 151520.)

Four

KERES PUEBLOS

Cochiti Pueblo, located on the west bank of the Rio Grande in north central New Mexico, is the first of the Keresan Pueblos. Unlike some of the neighboring pueblos, Cochiti welcomed Spanish settlers in the early 18th century, who became comrades in arms against Navajo raids.

Santo Domingo Pueblo is one of the larger pueblos in the central Rio Grande area. Its first village was established in 1776, but due to floods during the next century, it moved to higher ground, where it has been located since 1895.

San Felipe Pueblo was unable to hold off the Spanish during the Pueblo Revolt and its people had to retreat and live atop Horn Mesa, southwest of Cochiti Canyon, for many years.

The history of Zia Pueblo most succinctly tells the story of New Mexico's indigenous people and Spain's impact in its first 150 years of rule. From a population of at least 5,000 in 1540, Zia had less than 300 members in 1690, a result of the deaths and the scattering of its members to other areas during the revolt.

Santa Ana Pueblo is the last of the five eastern Keres-speaking pueblos located in the central Rio Grande Valley. The Pueblo of Santa Ana, along with that of Zia, was destroyed during the Pueblo Revolt. The revolt and aftermath caused repeated dislocations for the people at Santa Ana, who took refuge with other pueblos in the Jemez Mountains.

Laguna Pueblo was established mostly by Keresan refugees who chose not to return to their homes after the Spanish regained control in 1692. They formed their own pueblo 14 miles northeast of Acoma. Laguna Pueblo was formally established in 1699, seven years before the founding of the city of Albuquerque.

Acoma Pueblo is famous not only for its sweeping vistas high above its home on the mesa, but also for the brutal treatment it endured under Spanish rule. Juan de Oñate ordered the execution of many of the Pueblo men, while the ones who survived had one of their feet severed.

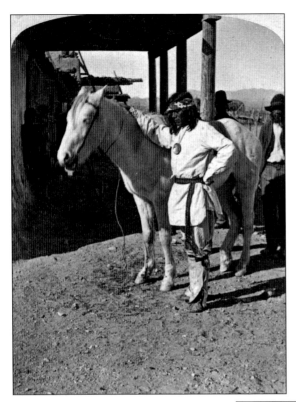

The ability to speak both Spanish and English, along with knowledge of the area, provided work for local Pueblo men as guides. Jose Hilario Montoya takes a break from his job as a guide next to his horse around 1866. (Photograph by William Henry Brown, Palace of the Governors [NMHM/DCA], No. HP.2013.33.12.)

After more than 25 years of working as an Indian guide, Jose Hilario Montoya became the governor of Cochiti Pueblo in 1891. He is pictured wearing a satin sash and traditional headband. (Photograph by Charles F. Lummis, Palace of the Governors [NMHM/DCA], No. 136373.)

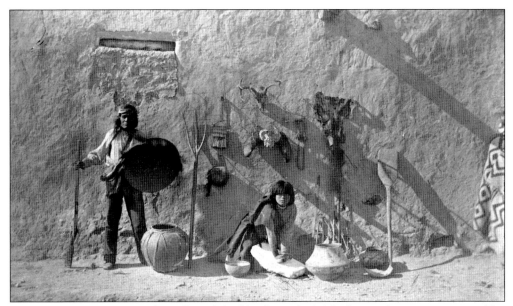

Juan Jose Montoya poses with a rifle and shield as his wife, Adelaida, grinds corn on a *metate* (flat oblong stone) in 1880 at Cochiti Pueblo. Prior to the Spanish colonization of New Mexico, the Pueblo people used bows and arrows for hunting; however, during the 18th century, they adopted the use of the rifle for hunting. (Photograph by George C. Bennett, Palace of the Governors [NMHM/DCA], No. 002490.)

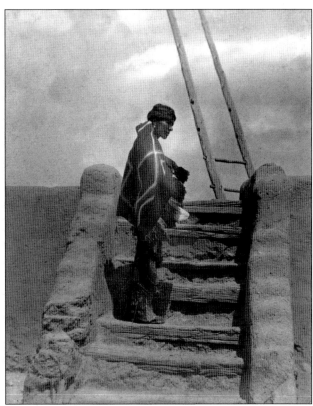

Copriano Guetano (Cipriano Suina) enters the Turquoise Kiva at Cochiti Pueblo in 1914. The ladder at the entrance was used to descend to the underground kiva. (Photograph by Carter H. Harrison, Palace of the Governors [NMHM/DCA], No. 146621.)

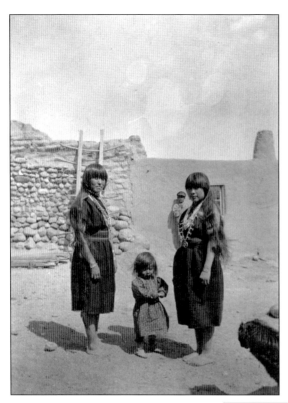

Ignacita Suina and Tri-Wah-Shutze are pictured with a young girl in front of an adobe house at Cochiti Pueblo around 1920. The responsibility of caring for the children was shared among the women, even if they were not related. (Palace of the Governors [NMHM/DCA], No. 002310.)

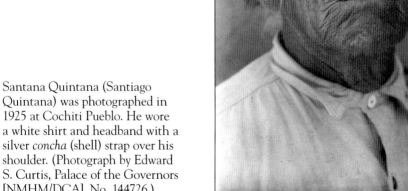

Santana Quintana (Santiago Quintana) was photographed in 1925 at Cochiti Pueblo. He wore a white shirt and headband with a silver *concha* (shell) strap over his shoulder. (Photograph by Edward S. Curtis, Palace of the Governors [NMHM/DCA], No. 144726.)

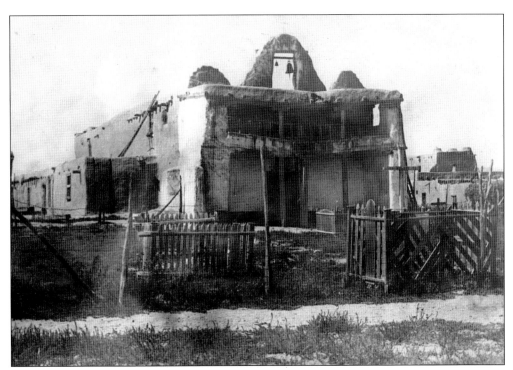

The Mission Church of San Buenaventura at Cochiti Pueblo was built around 1776, with ongoing additions in 1789 and 1796. In 1949, Fray Angelico Chavez, the first native-born New Mexican Franciscan, created restoration plans for the church, with work completed in the 1960s. This photograph of the church at Cochiti Pueblo was taken in 1899. (Photograph by Adam C. Vroman, Palace of the Governors [NMHM/DCA], No. 002301.)

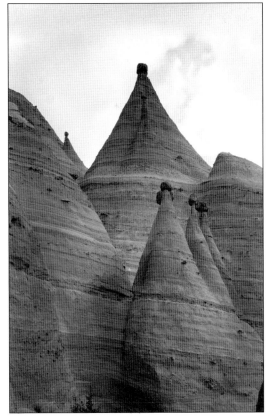

The Kasha-Katue Tent Rocks at Cochiti Pueblo are pictured in this photograph taken in 1925. The cone-shaped rock formations of pumice, ash, and tuffs are a result of volcanic eruptions that occurred between six and seven million years ago. The site became a US national monument on January 17, 2001, by a proclamation made by Pres. Bill Clinton. In the proclamation, it is observed that "it was not until the late eighteenth century that families began to claim land grants around Tent Rocks from the Spanish Crown." (Photograph by T. Harmon Parkhurst, Palace of the Governors [NMHM/DCA], No. 069994.)

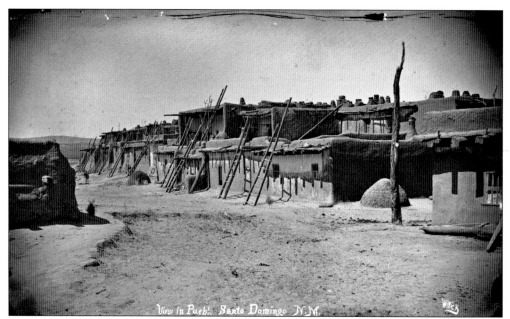

Santo Domingo Pueblo is located on the east side of the Rio Grande, 35 miles southwest of Santa Fe. The current site of the Santo Domingo Pueblo can be seen in this 1881 photograph; however, during the Spanish colonial era, the pueblo was located near the Camino Real and became one of the colonial mission headquarters in 1598. (Photograph by Ben Wittick, Palace of the Governors [NMHM/DCA], No. 016095.)

After repeated floods from the Rio Grande, a new location for the kiva at Santo Domingo Pueblo was established, as seen in this photograph taken in 1881. A portion of the wooden vigas that support the roof of the kiva circle the structure. (Photograph by Ben Wittick, Palace of the Governors [NMHM/DCA], No. 087135.)

This man was photographed at Santo Domingo Pueblo in 1925. He stands in front of an adobe building that was built after 1895, when the pueblo was reestablished on higher ground due to periodic flooding from the Rio Grande. (Photograph by Edward S. Curtis, Palace of the Governors [NMHM/DCA], No. 144713.)

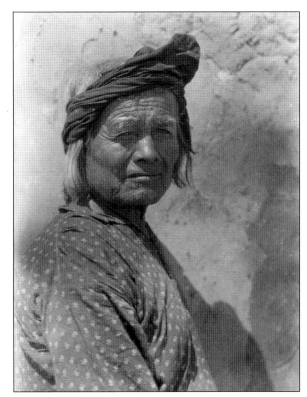

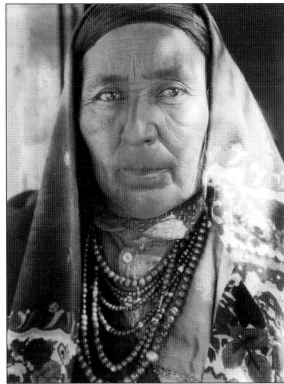

This woman was also photographed at Santo Domingo Pueblo in 1925. Her headscarf is indicative of Spanish customs brought to New Mexico by the European settlers who traveled along the Camino Real that ran beside the pueblo during the 17th and 18th centuries. (Photograph by Edward S. Curtis, Palace of the Governors [NMHM/DCA], No. 144710.)

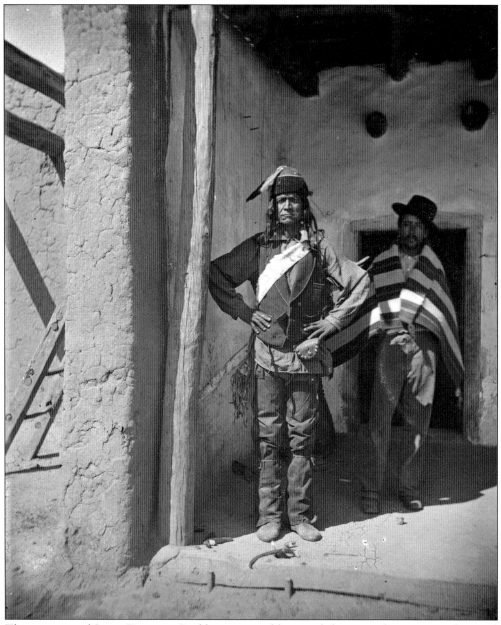

The governor of Santo Domingo Pueblo is pictured here with his second in command around 1883. The governor, on the left, wore a feather headband, while the man on the right sported a Spanish bolero hat. (Photograph by Ben Wittick, Palace of the Governors [NMHM/DCA], No. 070920.)

In 1776, materials pieced together from the remains of the Mission Church of the Pueblo of Santo Domingo, destroyed during the revolt, were used to rebuild the parish building. Fray Antonio Zamora was in charge of reconstructing the church. At the end the 19th century, the church was rebuilt on higher ground because of flooding. This c. 1880 photograph best represents the early 1776 church building. (Photograph by Adam C. Vroman, Palace of the Governors [NMHM/DCA], No. 164157.)

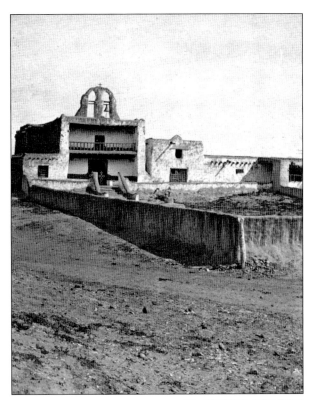

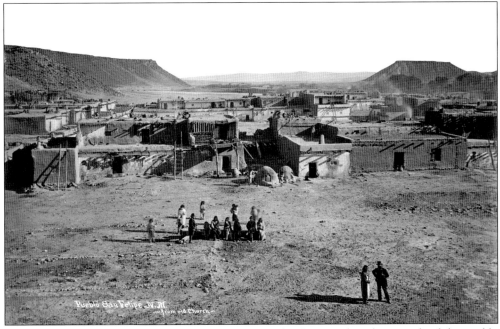

San Felipe Pueblo also took part in the Pueblo Revolt of 1680. This photograph of the pueblo was taken around 1880 near the Old Church, 650 feet above the pueblo with Black Mesa in the background. (Photograph by Ben Wittick, Palace of the Governors [NMHM/DCA], No. 016094.)

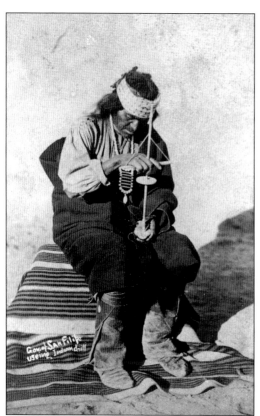

Pedro Jose Quivera served as the governor of San Felipe Pueblo in 1879. In this photograph, he demonstrates the use of a pump drill, a primitive tool that was used to drill holes in flat turquoise, shell beads, and wood. (Photograph by John K. Hillers, Palace of the Governors [NMHM/DCA], No. 003415.)

The Mission Church of Lord St. Phillip the Apostle at San Felipe Pueblo was built in 1706 following the reconquest of New Mexico by the Spanish in 1692. Fray Andrés Zevallos, who ministered to the pueblo from 1732 to 1741, began construction on a newer structure in 1736, with ongoing work completed by Fray Pedro Montaño in 1776. This photograph of the San Felipe Mission, taken in 1899, shows the additions to the church from the 18th-century construction. (Photograph by Adam C. Vroman, Palace of the Governors [NMHM/DCA], No. 012370.)

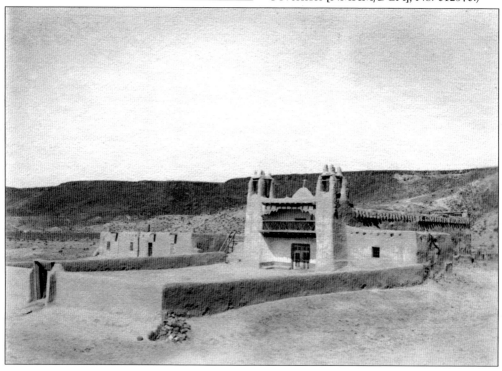

The people of Santa Ana speak Keres, and are among the seven Keres-speaking pueblos in New Mexico. Culturally, they are more similar to the other Keres pueblos in the central Rio Grande region than the people of the Laguna and Acoma Pueblos farther west. Although New Mexico's 19 Indian pueblos may speak different languages and differ in customs, they all utilize the kiva for their scared ceremonies. This c. 1925 photograph shows a Santa Ana Pueblo kiva. (Photograph by T. Harmon Parkhurst, Palace of the Governors [NMHM/DCA], No. 069603.)

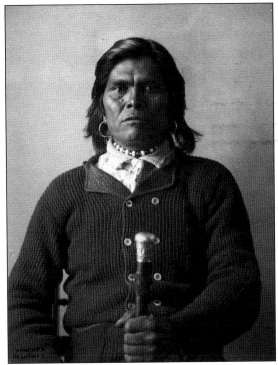

Santa Ana Pueblo took part in the Pueblo Revolt in 1680. The aftermath of the revolt led to repeated dislocations for the people of Santa Ana. They took refuge, along with other pueblos, in the Jemez Mountains. Jesus Antonio Moya, the governor of Santa Ana Pueblo in 1899, was photographed holding the symbolic silver-crowned cane of authority. (Photograph by Gil De Lancey, Palace of the Governors [NMHM/DCA], No. 059437.)

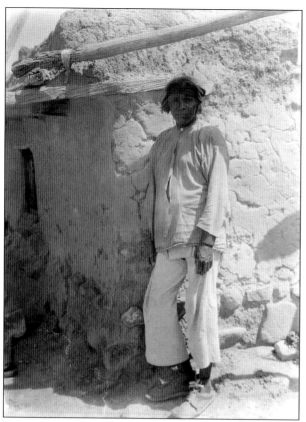

This man was photographed in 1925 at Santa Ana Pueblo. The patron saint for the pueblo is St. Anne, whose feast day is celebrated on July 26. (Photograph by Edward S. Curtis, Palace of the Governors [NMHM/DCA], No. 144725.)

This 1899 photograph shows the Mission Church at Santa Ana Pueblo that was originally built in 1693. The church was built with the help of carpenters from Pecos Pueblo under the supervision of Fray Francisco de Vargas, and a convent was added in 1696. By 1717, a new church was needed and Fray Pedro Montaño began work on that structure with Fray Diego Arias de Espinosa, completing the project in 1734. (Photograph by Adam C. Vroman, Palace of the Governors [NMHM/DCA], No. 143699.)

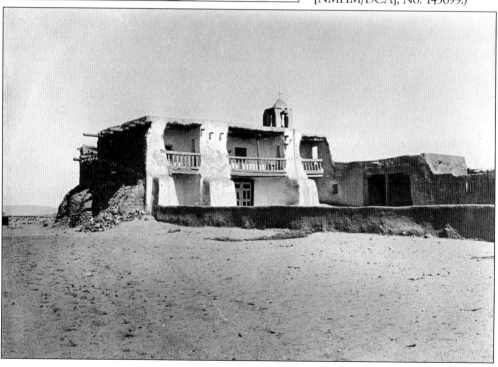

This boy's parents were executed for practicing witchcraft at Zia Pueblo in 1890, according to ethnologist Mathilda Coxe Stephenson. Stephenson was one of the first outsiders to document the superstitions surrounding witchcraft at Zia and Zuni Pueblos. (Photograph by Mathilda Coxe Stephenson, Palace of the Governors [NMHM/DCA], No. 082384.

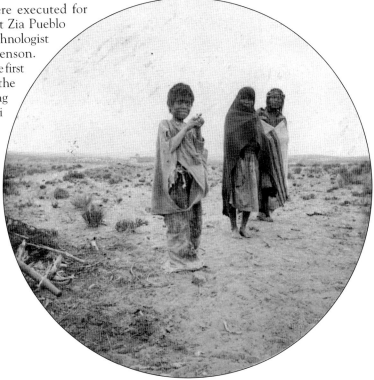

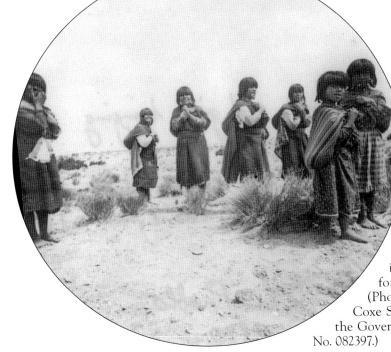

Women and children are transporting the clay that would be molded into the bricks used to build homes on the Zia Pueblo in 1890. Water gathered from the Jemez River, a tributary of the Rio Grande, was an important ingredient in the mixture used for the adobe bricks. (Photograph by Mathilda Coxe Stephenson, Palace of the Governors [NMHM/DCA], No. 082397.)

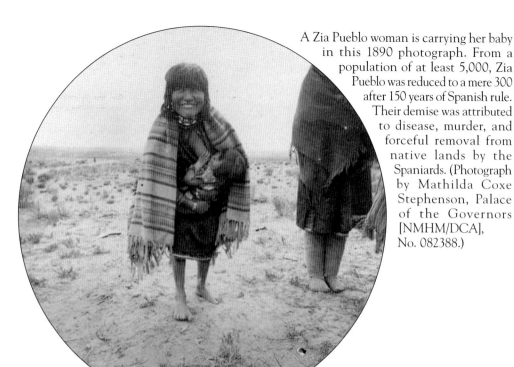

A Zia Pueblo woman is carrying her baby in this 1890 photograph. From a population of at least 5,000, Zia Pueblo was reduced to a mere 300 after 150 years of Spanish rule. Their demise was attributed to disease, murder, and forceful removal from native lands by the Spaniards. (Photograph by Mathilda Coxe Stephenson, Palace of the Governors [NMHM/DCA], No. 082388.)

This 1890 photograph shows a midwife and doctress participating in birth ceremonies at Zia Pueblo. While medicine men were called upon to minister to all types of ailments, it was the midwife who cared for pregnant women. Midwives served an important purpose on the pueblo well before colonists arrived. (Photograph by Mathilda Coxe Stephenson, Palace of the Governors [NMHM/DCA], No. 082392.)

A war dancer is preparing for a ceremonial dance at Zia Pueblo in 1925. Wearing a traditional feather headdress, the dancer uses a wooden club and shield for the ceremony. Prior to the introduction of wood carving tools by the Spanish colonists, animal bones were used as instruments. (Photograph by Edward S. Curtis, Palace of the Governors [NMHM/DCA], No. 144728.)

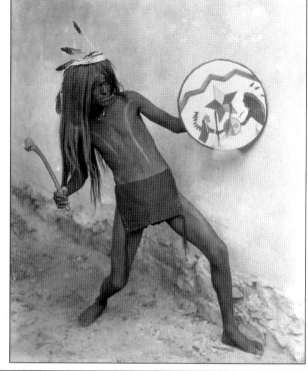

This 1925 photograph of the kiva at Zia Pueblo shows the stairs on the left leading to the ladder that provides access to the ceremonial chamber. (Photograph by Edward S. Curtis, Palace of the Governors [NMHM/DCA], No. 144724.)

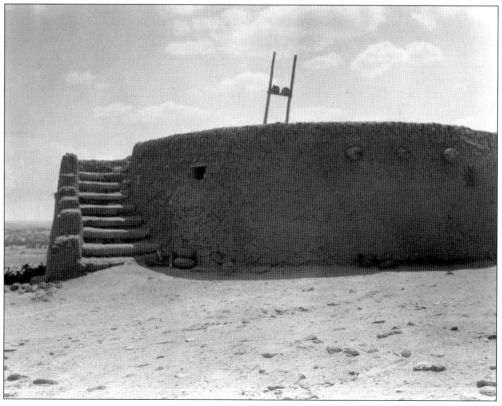

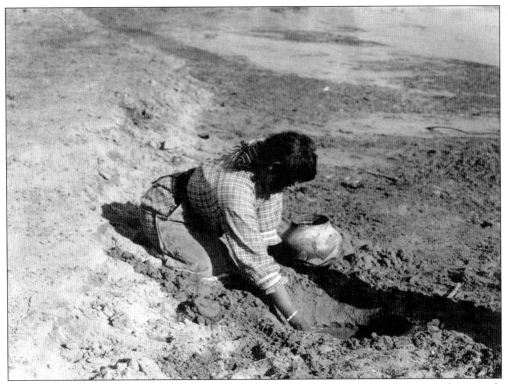

The woman in this 1920 photograph is digging for water at Zia Pueblo. In additional to hauling water from the river, women also sought out water sources closer to home when rainfall was abundant and the water table rose to just below the ground's surface. (Palace of the Governors [NMHM/DCA], No. 090904.)

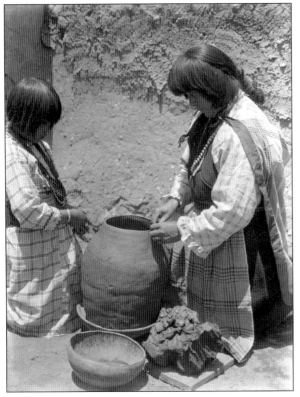

Tsipiai is teaching her daughter the art of pottery at Zia Pueblo in 1925. Once the clay pot is formed, it will be fired in an earthen kiln heated with animal manure. Traditionally, pottery was made by the women, who began to use clay pots instead of baskets. Prior to 1100 AD, the ancient Puebloans used baskets that were easier to transport. Once they settled along the Rio Grande, the clay pots proved to be more durable. (Photograph by Edward S. Curtis, Palace of the Governors [NMHM/DCA], No. 144706.)

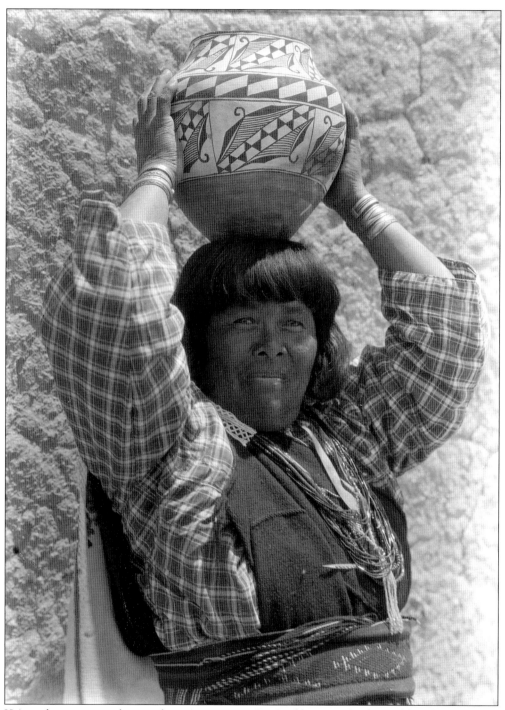

Ka'yati demonstrates the art of water carrying at Zia Pueblo in 1925. The pueblo is known for its polychrome pottery made from the clay in the surrounding mountains. (Photograph by Edward S. Curtis, Palace of the Governors [NMHM/DCA], No. 144661.)

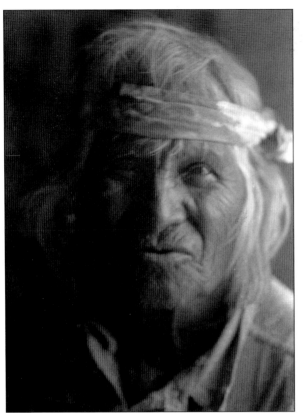

In 1687, the pueblos of Zia and Santa Ana were destroyed by the Spanish military under the direction of Pedro Reñeros de Posada. This man, who most likely had ancestors who were affected by the destruction of Zia Pueblo, was photographed in 1925 wearing a traditional headband. (Photograph by Edward S. Curtis, Palace of the Governors [NMHM/DCA], No. 144721.)

The Mission Church of Nuestra Señora de la Asunción at Zia Pueblo had to be rebuilt after its destruction during the Pueblo Revolt of 1680. Reconstruction of the church began with Fray Juan Alvarez in 1706 and was completed by Fray Manuel Bermejo in 1750. The mission church appears in this photograph taken in 1899, after several reconstruction phases. (Photograph by Adam C. Vroman, Palace of the Governors [NMHM/DCA], No. 012526.)

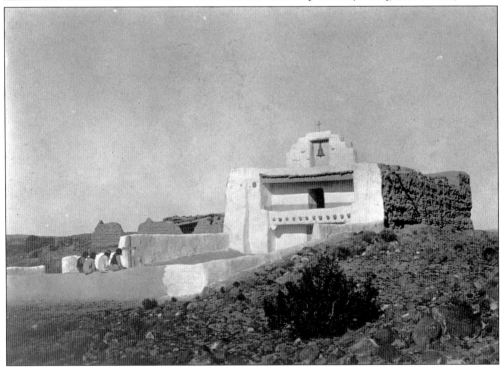

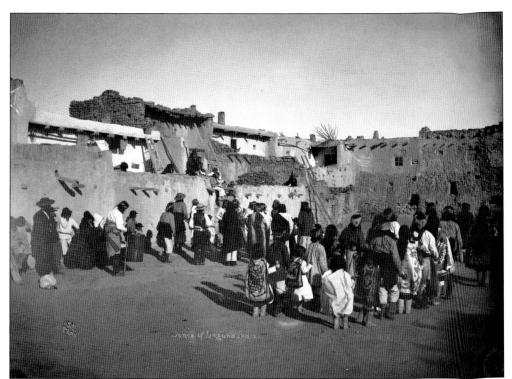

The Indians of Laguna Pueblo are preparing for the inauguration dance on January 12, 1887. Their multistory pueblo is visible in the background. (Photograph by Ben Wittick, Palace of the Governors [NMHM/DCA], No. 016349.)

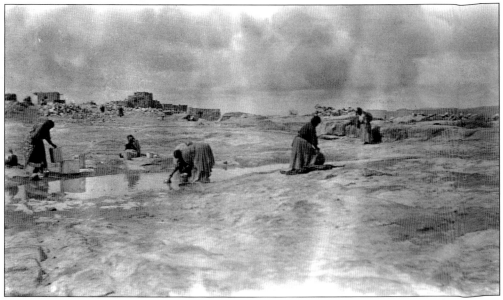

Laguna Pueblo women are collecting water near the pueblo around 1908. Unlike the Keresan pueblos to the north, Laguna did not have the Rio Grande as a water source and often had to depend on rainfall for water and the grains they stored during more fertile times for survival. (Photograph by H.F. Robinson, Palace of the Governors [NMHM/DCA], No. 036021.)

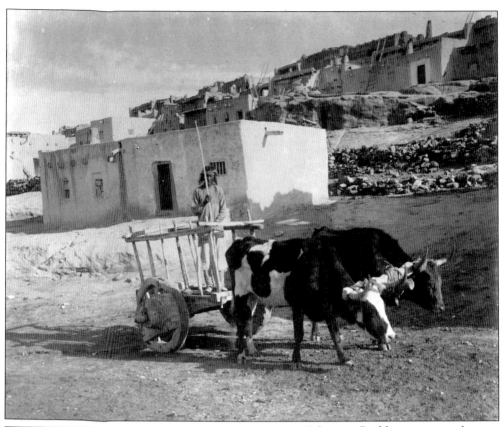

A Laguna Pueblo man is standing in his *carreta* (two-wheeled ox cart) in front of pueblo dwellings in this photograph taken in 1900. The carreta was introduced by Spanish colonists. The single-story adobe dwellings are situated at different levels on the pueblo, which provided greater visibility, offering safety from potential attacks by nomadic tribes. (Palace of the Governors [NMHM/DCA], No. 002892.)

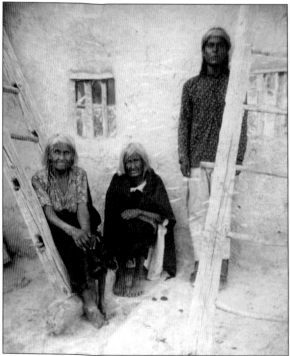

Two generations of a Laguna Pueblo family take a break on ladders to be photographed around 1880. Communication within multigenerational families was crucial to the survival of the Pueblo in the continuation of their language and history through oral traditions. (Photograph by Ben Wittick, Palace of the Governors [NMHM/DCA], No. 055007.)

Tzashima and her husband were photographed in front of a backdrop with pottery used as scenery around 1880. The photographs taken in a studio setting became a trademark for photographer Ben Wittick, who befriended many Native Americans in the Southwest. Wittick had a special kinship with the Hopi Indians, who allowed him to photograph their religious ceremonies. In fact, it was a Hopi medicine man who foretold his demise. He died from a rattlesnake bite at Fort Wingate in 1903. (Photograph by Ben Wittick, Palace of the Governors [NMHM/DCA], No. 015984.)

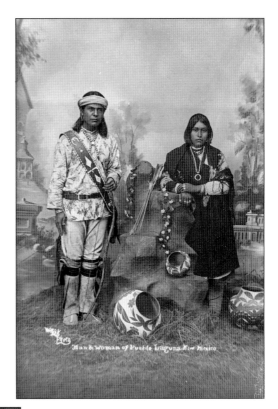

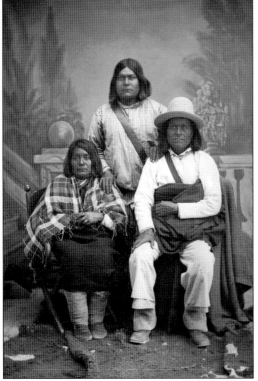

After the 1692 Spanish reoccupation, members of Cochiti, Santo Domingo, and Jemez Pueblos rebelled against Spanish control and over 100 fled to the isolated mesa at Acoma Pueblo. By 1697, they became disgruntled at Acoma and moved northeast 14 miles to establish Laguna Pueblo. Members of this family, photographed in 1882, were most likely descendants of Laguna's first settlement. Biso stands behind his parents Covy (seated) and Jose at Laguna Pueblo. (Photograph by Ben Wittick, Palace of the Governors [NMHM/DCA], No. 015980.)

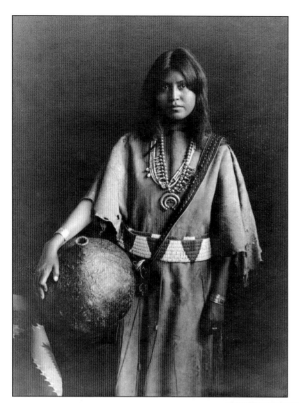

Loti is pictured with her pottery at Laguna Pueblo in 1907. She wore a traditional turquoise and silver squash blossom necklace with a leather shoulder strap and handwoven belt. (Photograph by Karl Moon, Palace of the Governors [NMHM/DCA], No. 146660.)

In addition to being responsible for bringing water to their village, the Laguna Pueblo women also collected the firewood, as seen in this c. 1915 photograph. These women wore plaid shawls to protect against the elements while out collecting wood. (Photograph Palace of the Governors [NMHM/DCA], No. LS.1527.)

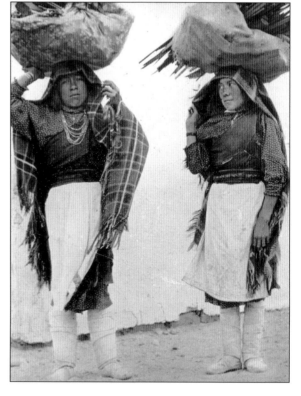

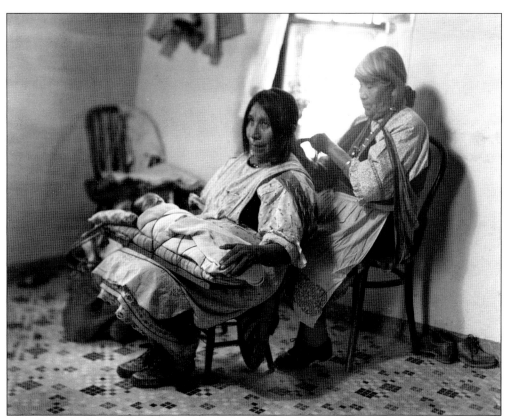

Mrs. Shijea (right) is braiding Mrs. Sarracino's hair as she sits with a baby on her lap at Laguna Pueblo around 1925. (Photograph by T. Harmon Parkhurst, Palace of the Governors [NMHM/DCA], No. 002041.)

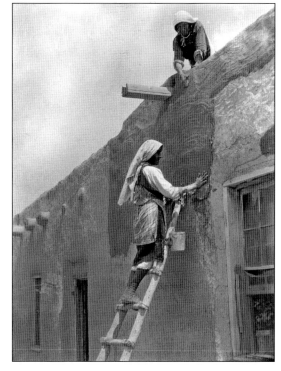

The annual tradition of re-plastering an adobe house was left to the women of Laguna Pueblo, as seen in this photograph taken in 1925. The Spaniards applied the same technique and referred to the women as *enjarradoras*, "the women who plaster." Due to the elements, the mud adobe houses had to be re-plastered to protect them from crumbling. (Photograph by Edward S. Curtis, Palace of the Governors [NMHM/DCA], No. 031961.)

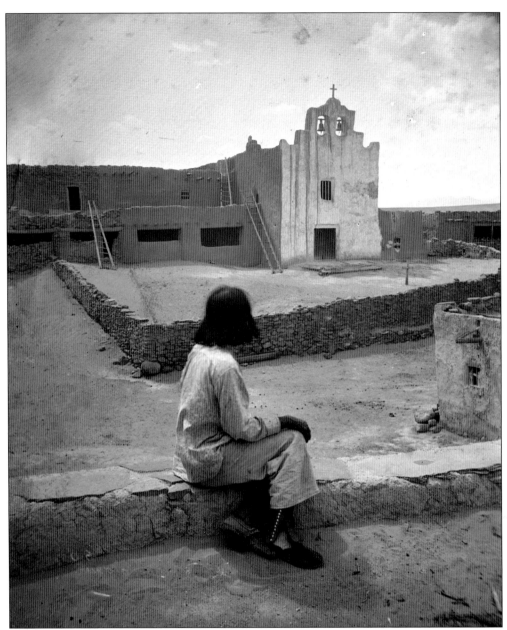

When the Mission Church of San Jose at Laguna Pueblo was built around 1706, it had 330 parishioners. A vertical sundial was designed on the south wall of the church, an indication that the Pueblo people integrated their own celestial beliefs into Catholicism. This photograph of the church was taken between 1880 and 1890. (Photograph by Ben Wittick, Palace of the Governors [NMHM/DCA], No. 015592.)

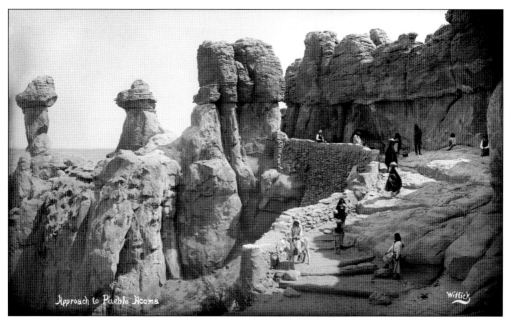

Built on a 350-foot sandstone bluff mesa, Acoma Pueblo has been in existence since at least 1150 AD. Charles F. Lummis, the ethnologist and archaeologist, describes the scene set in this 1880 photograph at Acoma Pueblo as "the most wonderful aboriginal city on earth, cliff built, cloud swept and with a church hardly less wonderful than the pyramids in Egypt." (Photograph by Ben Wittick, Palace of the Governors [NMHM/DCA], No. 016039.)

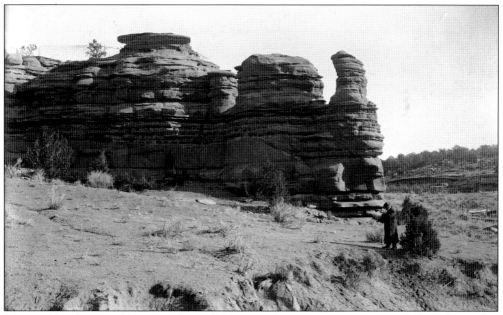

This c. 1880 photograph features the rock formation known as "Locomotive Cliff" on the road to Acoma Pueblo. The name was associated quickly after the arrival of the railroad to this region in the late 1870s. In ancient times, the Pueblo people climbed the cliff to their village. Later, roads were built so that they could reach the pueblo on horseback and wagons. (Photograph by Ben Wittick, Palace of the Governors [NMHM/DCA], No. 016028.)

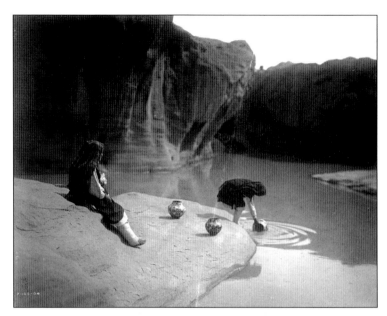

Behind the giant sandstone formations at Acoma Pueblo were ponds of water. These natural cisterns, photographed in 1904, provided the pueblo with a clean water source. Given their distance from the Rio Grande, they were convenient to the women who collected and carried water to their families each day. (Photograph by Edward S. Curtis, Palace of the Governors [NMHM/DCA], No. 076958.)

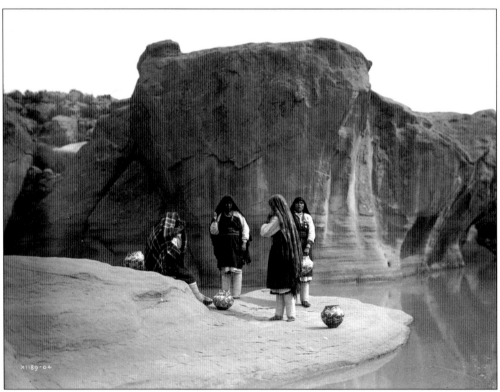

Like the modern-day office water cooler, the collection of water at the pond in Acoma provided time for women to catch up on local news and pueblo gossip. The woman to the right has discovered that the photographer has caught them taking a break from their daily responsibilities in this moment in 1904. (Photograph by Edward S. Curtis, Palace of the Governors [NMHM/DCA], No. 108109.)

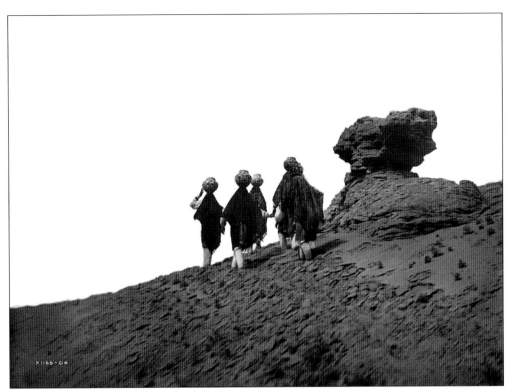

The water carriers are making the daily trek back to Acoma Pueblo from the cisterns in this 1904 photograph. With the exception of the woman on the left, the others manage the climb with a delicate balance and without the use of their hands. (Photograph by Edward S. Curtis, Palace of the Governors [NMHM/DCA], No. 144502.)

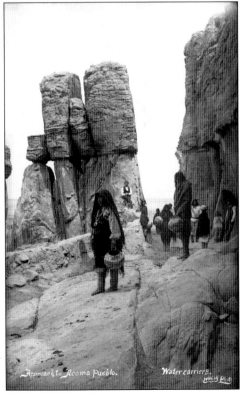

In this c. 1880 photograph, the water carriers are following a path, lined by monoliths, on the approach to Acoma Pueblo. This path has been traveled by the people of Acoma for centuries. (Photograph by Ben Wittick, Palace of the Governors [NMHM/DCA], No. 080022.)

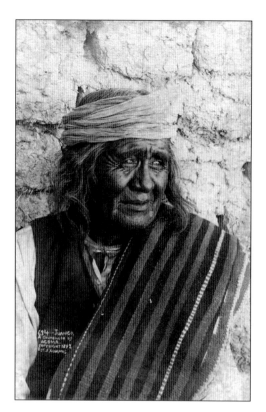

Juanico, a councilor of Acoma Pueblo, is featured in this photograph taken in 1892. As a pueblo councilor, he took part in shaping government policy on the pueblo. Juanico looks far off into the distance at the mesa, with an adobe building behind him. (Photograph by Charles F. Lummis, Palace of the Governors [NMHM/DCA], No. 002009.)

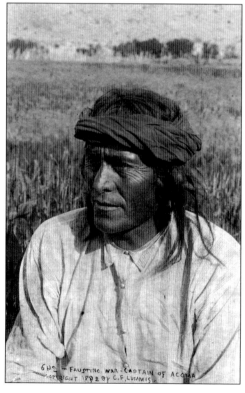

This war chief known as Faustino was photographed at Acoma Pueblo in 1892. As in any military organization, he led his people during conflicts. (Photograph by Charles F. Lummis, Palace of the Governors [NMHM/DCA], No. 136111.)

Juana, an Acoma Pueblo woman, is captured in this c. 1904 image wearing a patterned head covering with beaded and silver necklaces. (Photograph by Edward S. Curtis, Palace of the Governors [NMHM/DCA], No. 143714.)

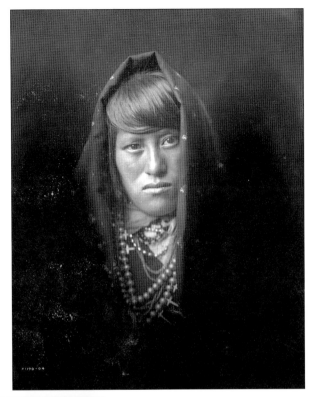

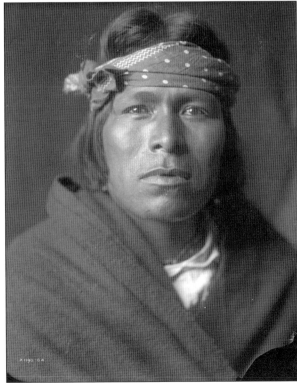

Selfon, an Acoma man, is seen in this 1904 photograph taken at Acoma Pueblo wearing a polka-dot headband and wrapped in a blanket. (Photograph by Edward S. Curtis, Palace of the Governors [NMHM/DCA], No. 143715.)

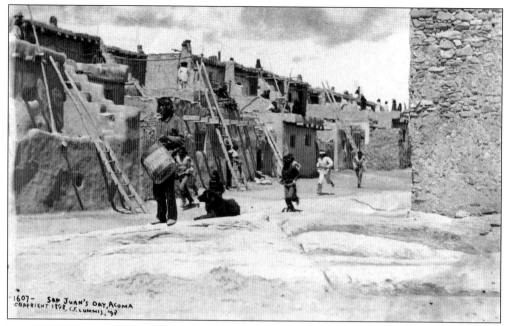

1607- SAN JUAN'S DAY, ACOMA
COPYRIGHT 1898, C.F. LUMMIS, '98

The Catholic feast day for St. John the Baptist is held on June 24. One of the ceremonial drummers was photographed during the 1898 San Juan feast day celebration at Acoma Pueblo. After the foot races, the pueblo would share in a feast of mutton, corn dishes, and chili products. (Photograph by Charles F. Lummis, Palace of the Governors [NMHM/DCA], No. 001925.)

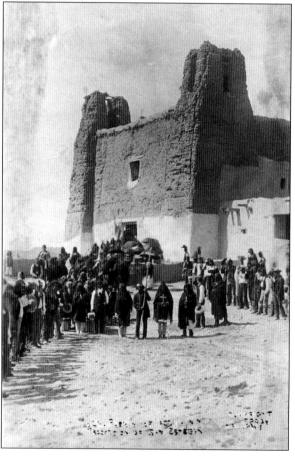

A procession was held in 1889 to honor San Estevan, the patron saint of Acoma Pueblo. The San Estevan Church is in the background. The original church was approximately 3,600 square feet and made of massive adobe bricks by the people of Acoma. The Catholic feast day for St. Stephen is held annually on September 2. (Photograph by Charles F. Lummis, Palace of the Governors [NMHM/DCA], No. 001926.)

People gathered at Acoma Pueblo for this event photographed in 1889. The terrace-like dwellings of the Acoma Pueblo provided a sweeping view of the surrounding area, an added safety element of this design. (Photograph by Charles F. Lummis, Palace of the Governors [NMHM/DCA], No. 002066.)

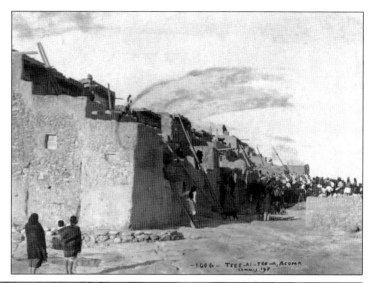

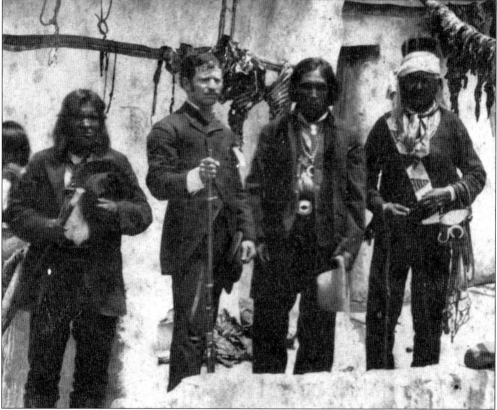

Thirty-seven years after New Mexico became a part of the United States, President Lincoln gave a silver-crowned cane, a tradition adopted from the Spanish, to each of the 19 pueblos to signify their sovereignty and as a symbol of respect for the pueblos' own authority. San Juan Garcia, at left, holds one of the canes, next to Solomon Bibo, Andres Ortiz, and Martin Valle at Acoma Pueblo in 1883. Bibo was the first and only non-Acoma appointed to serve as governor of the pueblo. (Photograph Palace of the Governors [NMHM/DCA], No. 164160.)

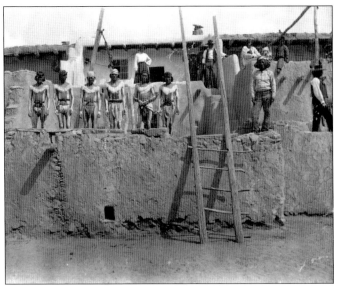

This group of Acoma men was photographed wearing ceremonial body paint in 1904. Ladders like those seen here are a ubiquitous part of the pueblo landscape. They provided rapid mobility from one end of the pueblo to the other, aiding warriors in the protection of the pueblo during wartime. (Photograph Palace of the Governors [NMHM/DCA], No. 044603.)

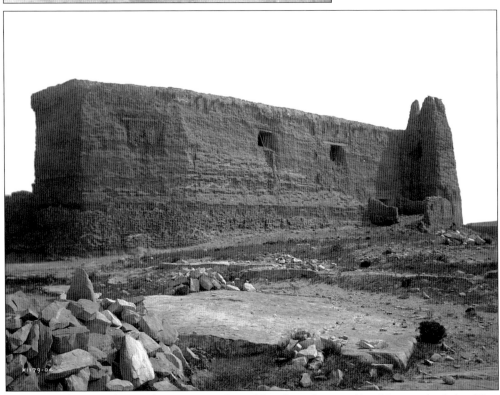

This 1905 photograph reveals remnants of an old wall made out of boulders to the left of San Estevan Mission Church at Acoma Pueblo. Construction of the first mission church began under the guidance of Fray Juan Ramirez in 1629 and was completed in 1641. The people of Acoma had to carry the massive stones for the foundation of the building up a high and treacherous footpath. The church at Acoma served as a fortress for nearby pueblos during the Pueblo Revolt. After the reconquest, the structure was once again used as a Catholic church. (Photograph by Edward S. Curtis, Palace of the Governors [NMHM/DCA], No. 144520.)

Five

ZUNI PUEBLO

Zuni Pueblo is the westernmost pueblo in New Mexico, located 125 miles west of the Rio Grande and 75 miles from Acoma Pueblo. It is the only pueblo in New Mexico to speak Zuni, a language unrelated to those of the other pueblos in the state. In 1776, Zuni was the largest village in New Mexico, with 1,617 people, more than the capital city of Santa Fe. Because of its distance from other settlements, Zuni had to endure the constant threat of attack by Apache and Navajo Indians. Its remote location was deemed by the Franciscan clergy as a "Christian outpost" that few wanted to serve. During the Pueblo Revolt, the people of Zuni took refuge atop the mountain mesas. They returned in 1692 to a single village from their former establishment that had consisted of five towns.

This isolation also fostered the witch mania that the Rio Grande pueblos of Zia, Sandia, Santa Ana, Santa Clara, and Nambe experienced during the 17th and 18th centuries. Spanish 17th-century colonial records refer to the witchcraft trials of that era, due in part to the European superstitions brought from the Old World. The plight of human misery was often blamed on the deliberate misuse of power by people knowledgeable in the black arts. Rock art discovered by archeologists often depicted carved or painted pictures at cliff dwellings of fetishes and ceremonial objects that strongly suggest the reality of otherworldly forces used by the earliest inhabitants of the Rio Grande Valley.

The earliest descriptions of the Zuni witch trials became known through the work of Frank Cushing and Mathilde Coxe Stephenson for the Bureau of Ethnology under the auspices of the Smithsonian Institute toward the latter part of the 18th century. By 1900, the American government began to take notice of the long-neglected Pueblo of Zuni and put an end to the executions by the Pueblo of people suspected of witchcraft that had added to the decline in population.

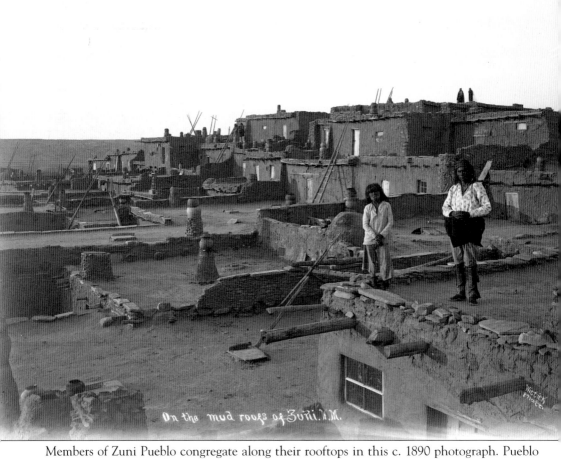

Members of Zuni Pueblo congregate along their rooftops in this c. 1890 photograph. Pueblo members can be seen all the way to the top right of the photograph. (Photograph by Ben Wittick, Palace of the Governors [NMHM/DCA], No. 016440.)

The Zuni language is unique to New Mexico and the Southwest. This Zuni couple was photographed on the pueblo around 1892. The woman maintains her traditional role as a water carrier while the man climbs a ladder to view the pueblo surroundings and ensure its safety. (Photograph by the Keystone View Company, Palace of the Governors [NMHM/DCA], No. 089327.)

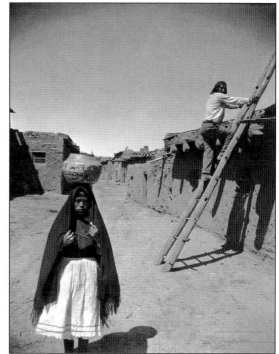

Wheat and corn became the major crops cultivated at Zuni Pueblo during the 17th century. This c. 1880 photograph shows Zuni women using oblong stones to grind corn. (Photograph by Ben Wittick, Palace of the Governors [NMHM/DCA], No. 016456.)

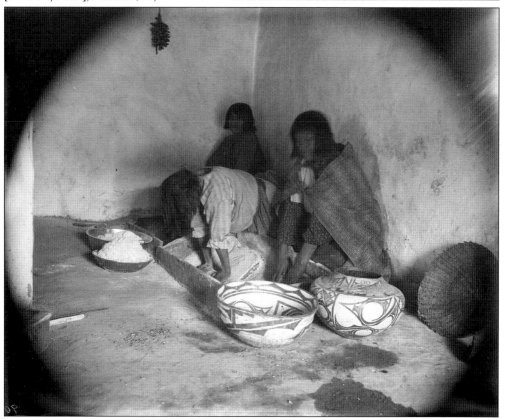

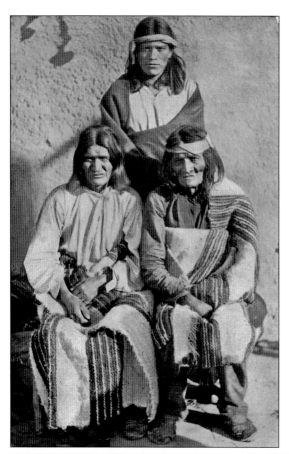

Members of the Pino family of Zuni Pueblo are shown in this 1879 photograph. Patricio Pino is seated on the left, and Pedro Pino sits next to him on the right. The man standing behind them is unidentified. (Photograph by John K. Hillers, Palace of the Governors [NMHM/DCA], No. 073899.)

The people of Zuni Pueblo continue to make the pottery, basketry, and jewelry their ancestors have handcrafted for centuries. This c. 1880 photograph illustrates indigenous pottery that was made for personal use and sometimes bartered for food and other necessities. (Photograph by Ben Wittick, Palace of the Governors [NMHM/DCA], No. 015990.)

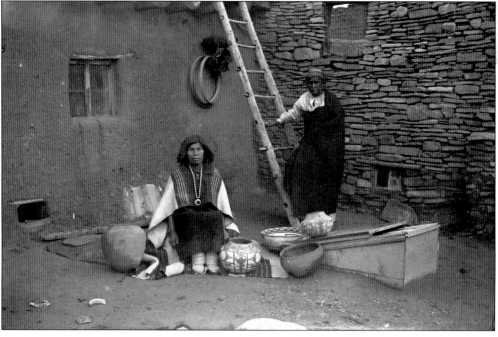

Pali-wah-ti-wa, the governor of Zuni Pueblo, was photographed in a studio setting around 1880. He wore a native squash blossom, a silver concha belt, and beaded shirt, pants, and moccasins. (Photograph by Ben Wittick, Palace of the Governors [NMHM/DCA], No. 016010.)

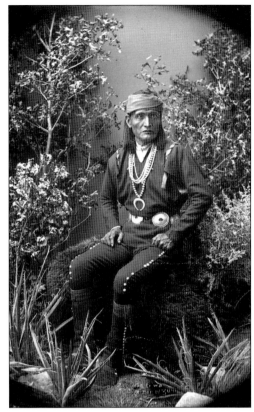

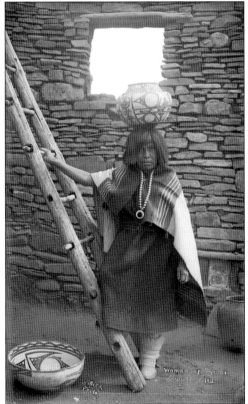

The wife of Zuni Pueblo governor Pala-wah-ti-wa poses next to her water *olla* (pot) around 1880. Despite her distinguished status as the governor's wife, Pala-wah-ti-wa brought water to her family daily. (Photograph by Ben Wittick, Palace of the Governors [NMHM/DCA], No. 016013.)

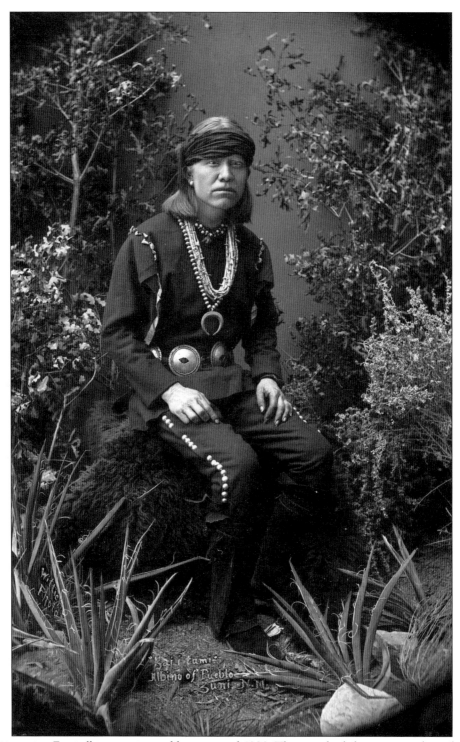

Kai-i-tumi, a Zuni albino, is pictured here around 1880. The man had the congenital condition known as albinism: the lack of pigmentation of the skin, hair, and eyes. (Photograph by Ben Wittick, Palace of the Governors [NMHM/DCA], No. 016007.)

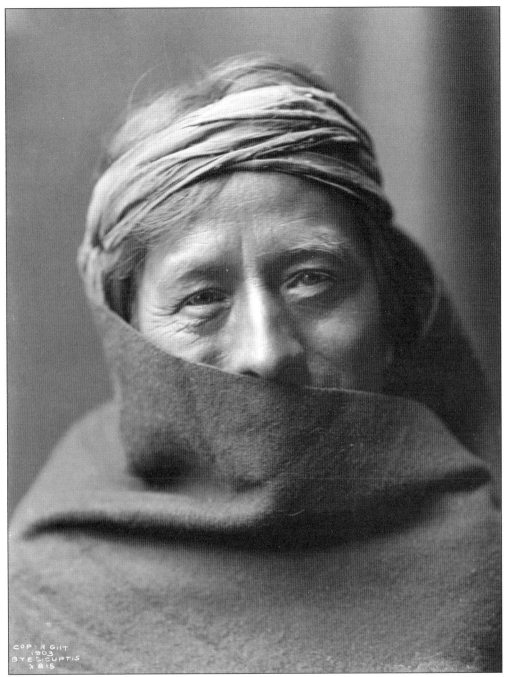

Waihusiwa poses for this 1903 photograph at Zuni Pueblo. A blanket was used to cover his mouth so that more emphasis was given to his eyes and forehead. (Photograph by Edward S. Curtis, Palace of the Governors [NMHM/DCA], No. 144530.)

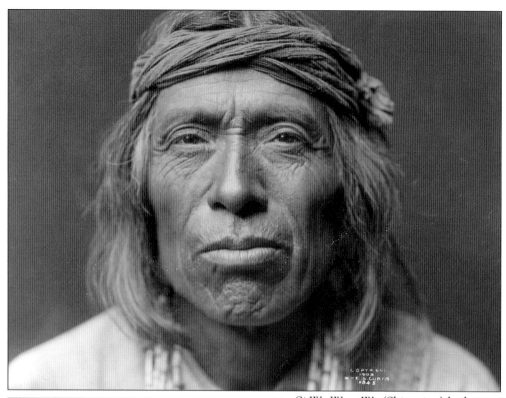

Si We Wata Wa (Shiwatiwa) looks directly at the camera in this 1903 photograph at Zuni Pueblo. He is wearing a traditional headband and beads. (Photograph by Edward S. Curtis, Palace of the Governors [NMHM/DCA], No. 143734.)

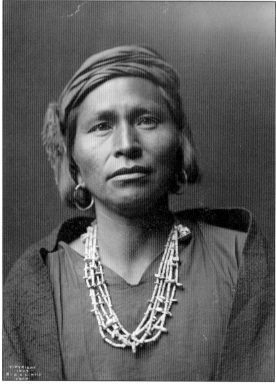

La Le La, a governor of Zuni Pueblo, is pictured in 1903. Silver was introduced to Zuni Pueblo by the Navajos in the 1850s. In this photograph, the governor wears silver earrings as part of his native attire in addition to beads and a headband. (Photograph by Edward S. Curtis, Palace of the Governors [NMHM/DCA], No. 143711.)

Lu-u-s is pictured with pottery balanced on her head at Zuni Pueblo in 1903. The half-moon shape of the container indicates that it was most likely used for food rather than the large jars used to carry water. (Photograph by Edward S. Curtis, Palace of the Governors [NMHM/DCA], No. 144508.)

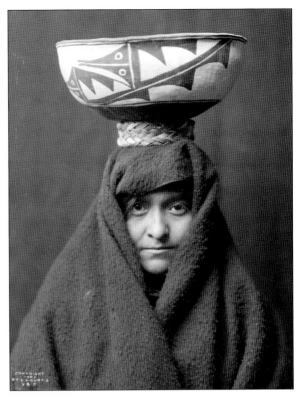

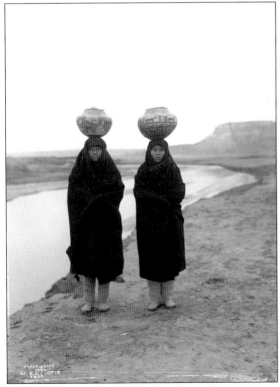

Like all of the other pueblos in the arid climate of New Mexico, the Pueblo of Zuni lived through numerous droughts. Cultivating water for drinking and irrigating crops was crucial to the Pueblos' existence. This photograph of two Zuni women on the riverbank was taken in 1903. It was likely taken during a drought, given the low level of the river. (Photograph by Edward S. Curtis, Palace of the Governors [NMHM/DCA], No. 076957.)

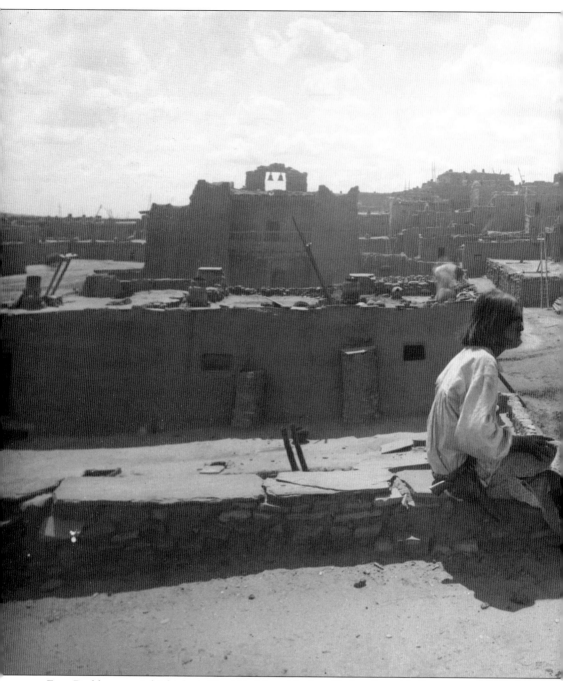

Four Pueblo men sit high above Zuni Pueblo, with the old church and bell tower in the distance, around 1880. The famous witch trials at Zuni took place in the vicinity of the church plaza through the end of the 19th century. The earliest description of the trials came to light when ethnologist Frank Hamilton Cushing of the Bureau of Ethnology befriended people at the pueblo in 1881. Once he gained their trust, he was privy to the innermost practices of the Sacred Bow Priesthood, Zuni's most notorious priesthood. It was the responsibility of the Sacred Bow Priesthood to determine and implement punishment upon those suspected of practicing witchcraft. The torture and slaughter of

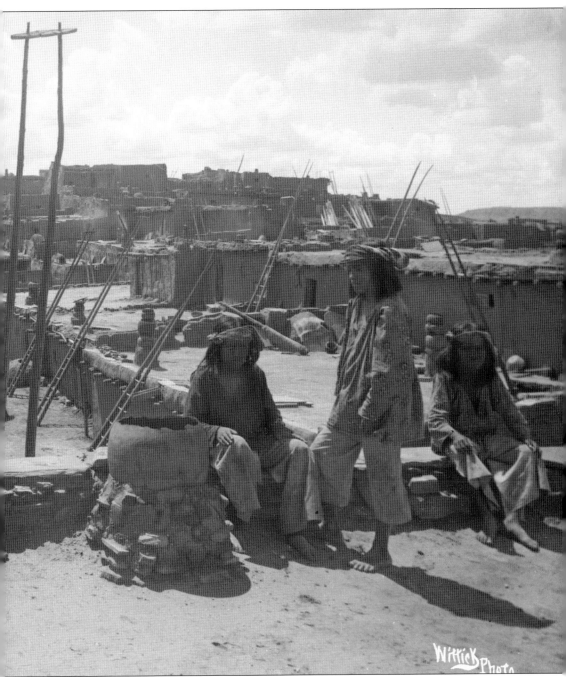

"witches" became a common and accepted practice on the pueblo. A decade later, anthropologist Mathilda Coxe Stephenson conducted similar research at Zuni Pueblo, affirming Cushing's claims highlighting the Pueblo's preoccupation with witchcraft and the extreme punishments they enforced. These public practices came to an end in the early 1900s when the US government, informed by the work of Cushing and Stephenson, prohibited such executions, engaging soldiers at nearby Ft. Wingate to enforce laws prohibiting public torture and execution. (Photograph by Ben Wittick, Palace of the Governors [NMHM/DCA], No. 015596.)

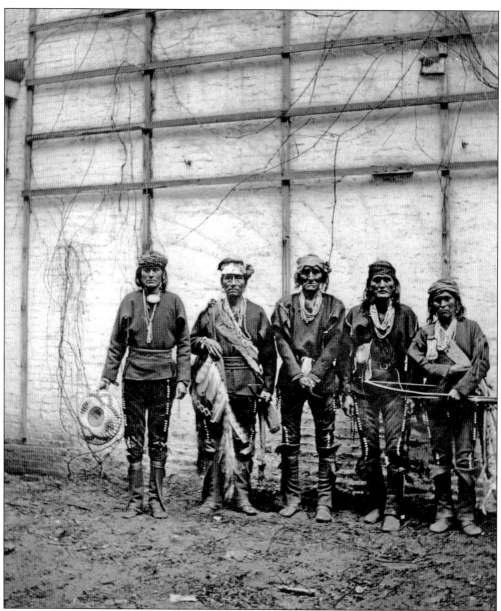

In the summer of 1881, Frank Hamilton Cushing took a group of tribal leaders from Zuni Pueblo to the East Coast. They traveled by train and were welcomed to the nation's capital by Pres. Chester A. Arthur. They went on to Boston, where they performed an ancient ceremony to replenish the Atlantic Ocean. When the group continued to Salem, Massachusetts, the Zuni men publicly commended the citizens for their ancestors' diligent persecution of those tried at the Salem Witch Trials during 1692–1693. The *Boston Herald* reported on the outcome of this visit, leaving its readership flummoxed and reticent—not wanting to relive that dark era in their history. (Photograph by Benjamin West Kilburn, Palace of the Governors [NMHM/DCA], No. 089333.)

Marita, an elderly Zuni woman, was accused of witchcraft and tortured by the "Priests of the Bow." Documentation accompanying this photograph claims that Marita was rescued by Protestant missionaries in 1897. Pueblo people were regularly tortured and threatened with execution until they "confessed" to practicing witchcraft. (Photograph by Ben Wittick, Palace of the Governors [NMHM/DCA], No. 015998.)

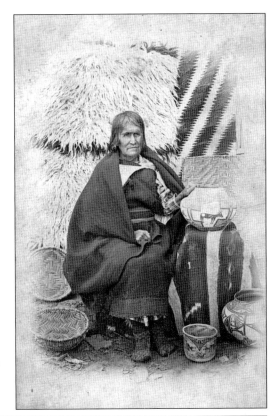

The people at Zuni Pueblo sought the help of medicine men in warding off and extracting spells brought on by witches, although medicine men were sometimes accused of witchcraft by the same people who sought their help in warding off evil spirits. In this 1905 photograph, a medicine man mixes medicinal herbs. (Photograph by Edward S. Curtis, Palace of the Governors [NMHM/DCA], No. 143713.)

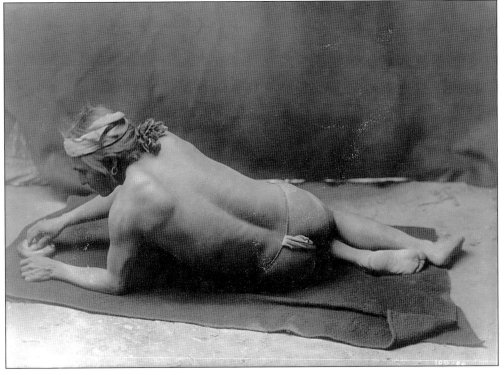

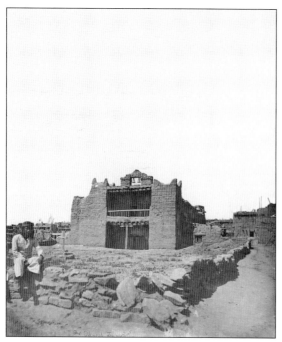

The Mission Church of Nuestra Señora de Guadalupe at Zuni Pueblo was destroyed during the Pueblo Revolt. From 1699 to 1706, Fray Juan de Garaycoechea used pre-1680 fabric in reconstructing the mission. In 1776, Zuni was the largest pueblo in New Mexico and was considered an outpost. For the clergy, it was more like Siberia, and the priests who had committed any type of infraction were quickly sent to Zuni Pueblo. During the latter part of the 18th century and into the 19th century, it was difficult to keep a permanent priest in residence, so the church fell into disrepair. This c. 1895 photograph of the mission marks the beginning of the reconstruction efforts that would continue through 1969. (Photograph, Palace of the Governors [NMHM/DCA], No. 014417.)

The ancient Tiwa name for Sandia Pueblo is Nafiat, "place where the wind blows dust." During the 16th century, the Spanish colonists renamed the mountain range Sandia, the Spanish word for "watermelon," because of the red glow on the mountains at sunset. The Sandia Mountains are a backdrop to this c. 1919 photograph at an event at Sandia Pueblo. (Photograph by Alabama Milner, courtesy Special Collections/Center for Southwest Research, [UNM Libraries], No. 2015-008 [3]-0140.)

Six

Southern Tiwa Pueblos

Sandia and Isleta are the only two pueblos in New Mexico that speak Southern Tiwa. For unknown reasons, Sandia Pueblo has been ignored by historians and anthropologists, and there is less documentation on its history. What is known about the pueblo, which is located 15 miles north of Albuquerque, is that prior to 1680 it had a population of at least 3,000. Many of its people were either killed during the Pueblo Revolt or fled for their safety. By 1733, the pueblo had been abandoned, and not until 1748 did the people return from Hopi land. Historical records indicate that when Sandia was resettled, it was a mix of refugees from various pueblos and that it had possessed different characteristics prior to the revolt. With the new settlement, Sandia now had a strong Keresan influence, more so than any other non-Keres pueblo.

Isleta Pueblo was on friendly terms with the Spaniards and allowed them to take refuge during the Pueblo Revolt. However, they were not spared from the violence that surrounded them and soon fled south to El Paso and Mexico. Upon their return after 1692, the pueblo once again prospered due in part to its location. Its proximity to the Rio Grande allowed its people to irrigate their fields regularly. Unlike some of the pueblos to the west, Isleta was not dependent on dry farming and the coming of rain for their survival.

During the last quarter of the 19th century, Isleta experienced a transformation when a group from Laguna Pueblo became a part of their pueblo. This integration occurred when three Laguna women married Protestant men, which caused a fissure at the pueblo. The newcomers wanted the Pueblos to break away from the stronghold of three centuries of Catholicism. Unable to contend with the strife, several families fled to Isleta. Like the Spanish families who sought refuge in 1680, Isleta once again provided a new home for people in need.

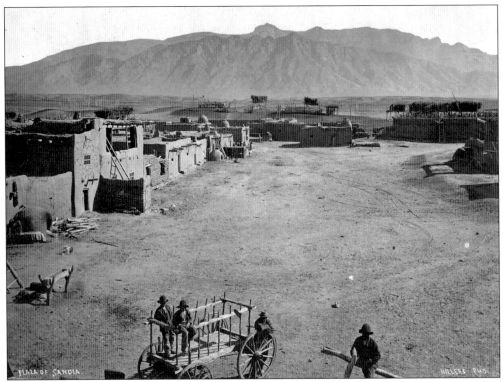

Sandia Pueblo, which is 15 miles north of Albuquerque, has been in its current location since 1539. During the Pueblo Revolt of 1680, the Pueblo people fled to Hopi lands. The pueblo remained abandoned until 1748, when the people of Sandia Pueblo returned to be close to their sacred mountain. A mixed group of refugees, who had fled from several pueblos during the turbulent Spanish Reconquest, came with them to resettle the land shown in this 1879 photograph that showcases the Sandia Mountains in the background. (Photograph by John K. Hillers, Palace of the Governors [NMHM/DCA], No. 003371.)

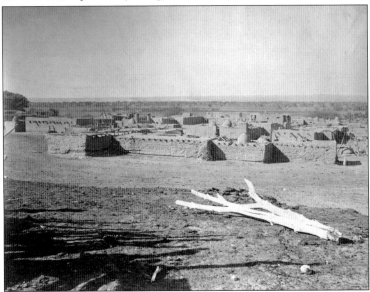

Mysteriously, archeologists and historians in New Mexico have dedicated significantly less attention to studying Sandia Pueblo. In this photograph of the dwellings of Sandia Pueblo taken around 1879, the pueblo appears deserted. (Photograph by John K. Hillers, Palace of the Governors [NMHM/DCA], No. 029890A.)

Mariano Carpentero, a tribal chief at Sandia Pueblo in 1899, was photographed for the Smithsonian Institute's Bureau of Ethnology in Washington, DC. Carpentero chose to be photographed with the Lincoln cane of Pueblo authority. (Photograph by Gil De Lancey, Palace of the Governors [NMHM/DCA], No. 073899.)

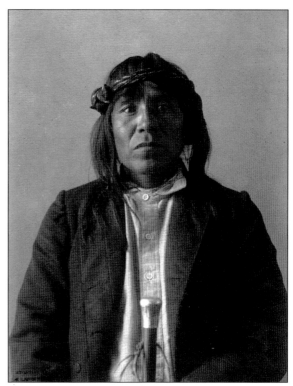

In 1681, the people of Sandia Pueblo burned the chapel and convent of St. Anthony, built in 1610, in retaliation against Spanish authority. Reconstruction of the church began in 1752 and was completed in 1784. The church was rechristened Nuestra Señora de los Dolores de Sandia. Later, the church, shown in this 1899 image, was changed back to its first patron saint, St. Anthony de Padua. (Photograph by Adam C. Vroman, Palace of the Governors [NMHM/DCA], No. 014419.)

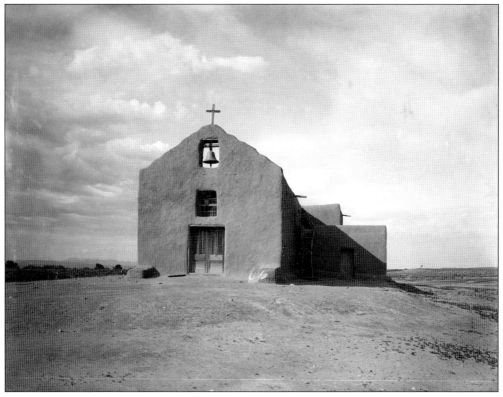

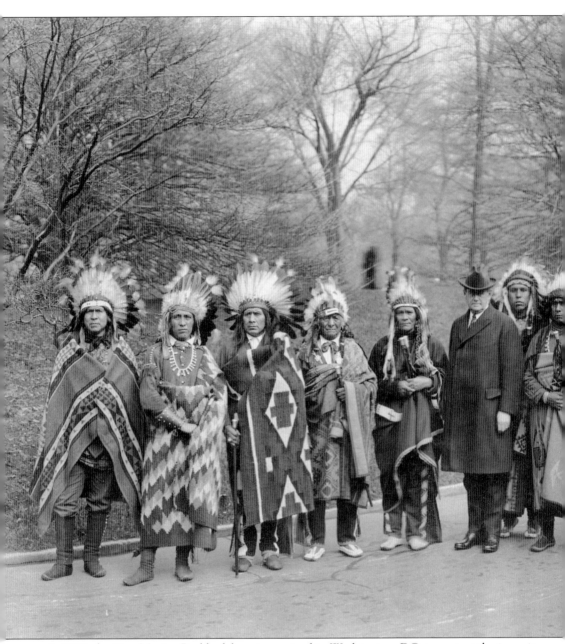

In 1923, the New Mexico Pueblo delegation arrived in Washington, DC, to protest the inequity of the Bursum Bill. Introduced to Congress in 1922 by Sen. Holm Olaf Bursum of New Mexico, the proposed legislation pertained to land titles within the Pueblo Indian land grants. Far from providing justice for the native people, the bill would have deprived them of 60,000 acres of their ancestral land and access to water, benefiting trespassers by confirming that all non-Pueblo land claims made 10 years prior to New Mexico becoming a state in 1912 would take precedent. The

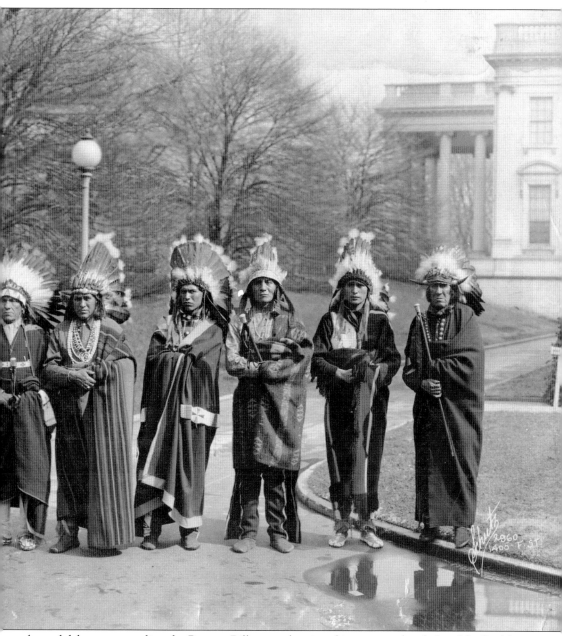

heated debate surrounding the Bursum Bill aroused national interest in the plight of the Pueblos and paved the way for future reforms in government policy toward Native Americans. Pres. Calvin Coolidge poses at center with Pueblo governors and members of the All-Pueblo Council, from left to right, Juan Avila (Sandia), Santiago Naranjo, (Santa Clara), Martin Vigil (Tesuque), Sotero Ortiz (Ohkay Owingeh), Jose Alcario Montoya (Cochiti), and other members of the delegation. (Palace of the Governors [NMHM/DCA], No. 047827.)

Simon Zuni was governor of Isleta Pueblo in 1865. That year, he was presented with one of the 19 silver canes gifted by President Lincoln as a tribute to the authority of their tribal government. The gift came a few months before the president was assassinated. Zuni is seen in this photograph taken at Isleta Pueblo in 1900. (Photograph by Sumner W. Matteson, Palace of the Governors [NMHM/DCA], No. 001925.)

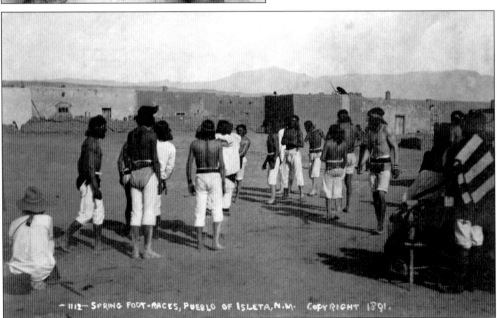

-1112- SPRING FOOT-RACES, PUEBLO OF ISLETA, N.M. COPYRIGHT 1891.

Isleta Pueblo was named San Agustin de la Isleta by the Spanish colonists for its patron saint and its proximity to the Rio Grande. The people of Isleta maintained a distant but somewhat harmonious relationship with the Spaniards. These Isleta Pueblo men are preparing for foot races in 1891, an ancient tradition that began prior to the arrival of the Spanish colonists. (Photograph by Charles F. Lummis, Palace of the Governors [NMHM/DCA], No. 136079.)

During the last quarter of the 19th century, the Isleta Pueblo accepted the disenfranchised people of Laguna Pueblo, changing the pueblo's cultural fabric. The advent of the railroad in 1879 brought a surge in population near Laguna Pueblo that would include Protestant missionaries who worked to release the three-century grip that Catholicism had retained over the pueblos. Three women from Laguna Pueblo married Protestant men, who in turn began to call for change. The pueblo became divided between traditionalists and revolutionaries. Top officials of the traditionalist branch sought refuge at Isleta Pueblo, where their ceremonial practices were permitted. Of the approximately 28 families who fled to Isleta, two known surnames were Abeita and Chiwiwi. These photographs of Juan Rey Abeita (right) and Lupe Chiwiwi (below) were most likely taken between 1880 and 1890. (Right, photograph by Charles F. Lummis, Palace of the Governors [NMHM/DCA], No. 002683; below, photograph by Ben Wittick, Palace of the Governors [NMHM/DCA], No. 052331.)

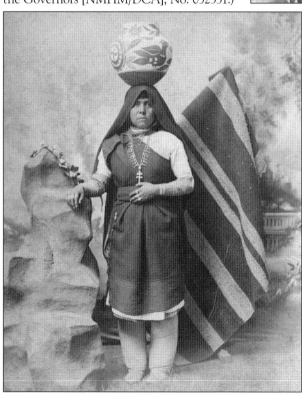

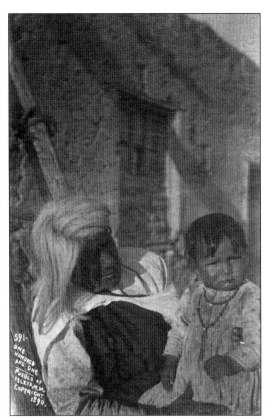

A 101-year-old woman holds a baby at Isleta Pueblo in 1890. The woman was born in 1789, a century after the return of the people of Isleta to their pueblo following the revolt of 1680. (Photograph by Charles F. Lummis, Palace of the Governors [NMHM/DCA], No. 136238.)

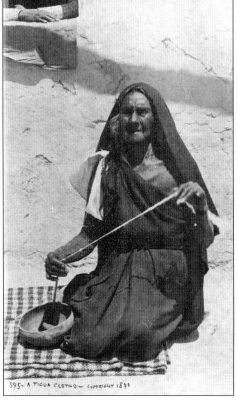

A woman spins wool at Isleta Pueblo in 1890. Textiles, along with jewelry and pottery, were made by the people of Isleta Pueblo for personal use and to barter for goods. (Photograph by Charles F. Lummis, Palace of the Governors [NMHM/DCA], No. 136359.)

The Feast Day of the Dead at Isleta Pueblo is held in accordance with the Catholic calendar on November 2, All Soul's Day. Bowls are traditionally lined with upright ears of corn and other favorite foods of the deceased. The offering is taken to the unmarked graves of relatives, where they are placed with lit candles lining each grave. A woman at Isleta Pueblo prepares her offering for the dead in this 1888 photograph. (Photograph by Charles F. Lummis, Palace of the Governors [NMHM/DCA], No. 136371.)

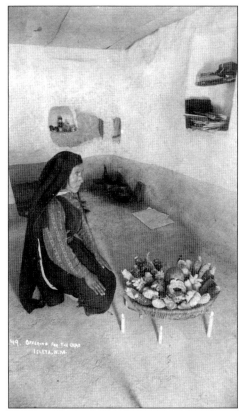

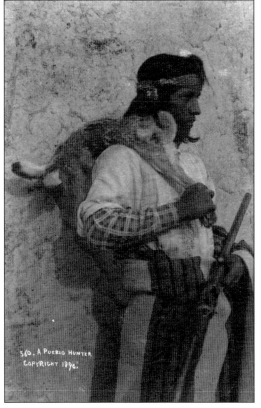

Okoya-pis, an Isleta Pueblo hunter, is pictured with his daily catch over his shoulder in 1890. Rabbit hunting was common around the Manzano Mountains east of the pueblo. The Pueblo people also fished along the Rio Grande and in surrounding mountain streams. Isleta was not restricted to dry farming like some of the other pueblos after its people diverted water from the Rio Grande using four ditches to irrigate crops. In 1890, Isleta Pueblo had one of the largest orchards in the area that contained 60 acres of peach, plum, and apricot trees. (Photograph by Charles F. Lummis, Palace of the Governors [NMHM/DCA], No. 002680.)

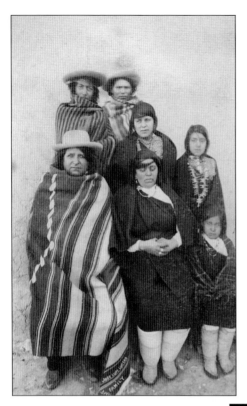

The Jose Lupi (Lupe) family was photographed at Isleta Pueblo around 1885. The family wore traditional native clothing, but the men accessorized, donning bolero-style hats that hinted of a Spanish influence. (Photograph by Calvin W. Brown, Palace of the Governors [NMHM/DCA], No. 102143.)

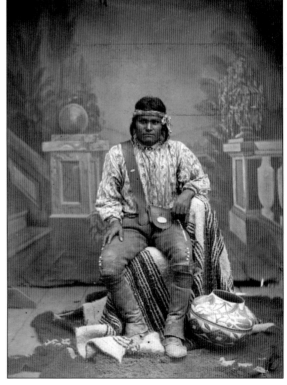

Hash-i-wi-wi sits for a portrait photograph at Isleta Pueblo with a studio backdrop and pottery décor around 1880. The people of Isleta, who were friendly with the Spanish during the 17th century, were more open to other outside influences than many of the pueblos to the north. Studio portraits like this, taken by traveling photographers, became common. (Photograph by Ben Wittick, Palace of the Governors [NMHM/DCA], No. 016153.)

This Tigua knitter was photographed in 1892 at Isleta Pueblo. During the Pueblo Revolt, the people of Isleta sought refuge in El Paso del Norte. After the Spanish Reconquest, some of the Isleta Pueblo decided to stay in their new pueblo called Ysleta del Sur and became known as the Tigua Indians. The people of the two pueblos became interchangeable as they moved back and forth visiting relatives in the north and the south. Ysleta del Sur Pueblo is a federally recognized contingent of the Pueblos of New Mexico. This Tigua woman does her work seated next to an adobe house in front of a window protected with wooden slats. (Photograph by Charles F. Lummis, Palace of the Governors [NMHM/DCA], No. 036307.)

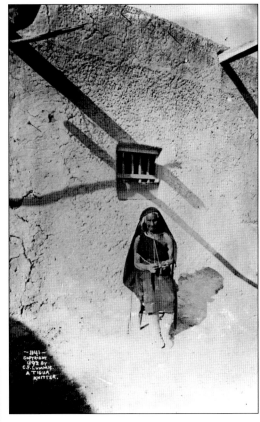

This young woman was described as a "Tigua Maiden" by visiting archaeologist Charles F. Lummis at Isleta Pueblo in 1894. Perhaps it was her beautiful long hair that prompted Lummis to describe her as a maiden, an archaic term for an unmarried woman. (Photograph by Charles F. Lummis, Palace of the Governors [NMHM/DCA], No. 036293.)

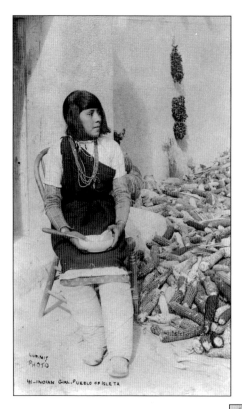

Mitsha prepares a dish of food at Isleta Pueblo around 1895. She is seated next to the annual harvest of corn that has been set out to dry. At the end of each harvest season, stalks of corn are dried to preserve them for the winter. (Photograph by Charles F. Lummis, Palace of the Governors [NMHM/DCA], No. 002700.)

Felicia polishes her pottery in this 1925 photograph taken at Isleta Pueblo. Designs are applied before the pottery is heated in the kiln. After the heating process, paint is sometimes added to the design. An old, cracked adobe wall is behind her. (Photograph by Edward S. Curtis, Palace of the Governors [NMHM/DCA], No. 144704.)

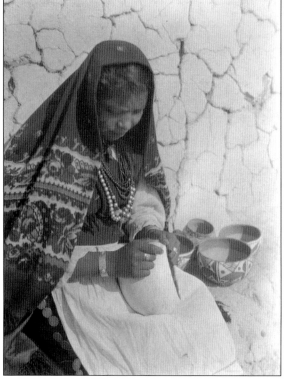

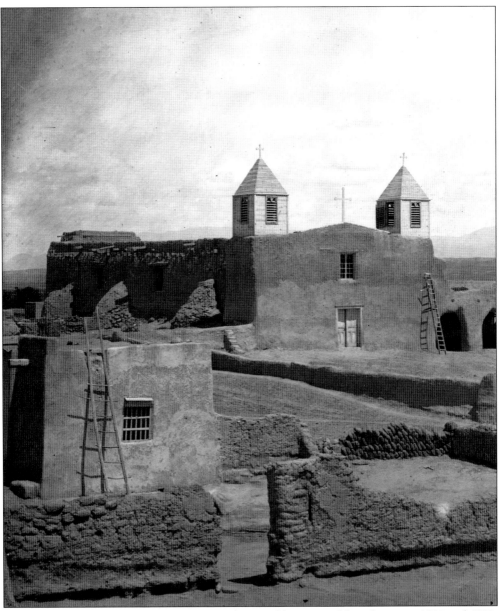

The Mission Church of San Augustine at Isleta Pueblo, pictured here between 1880 and 1890, was built around 1613. Phases of reconstruction of the church after the Pueblo Revolt of 1680 began in 1710 and were completed in 1776 under the guidance of Bishop Pedro Tamaron. The original church was built close to the Rio Grande, which caused periodic flooding. During a reconstruction effort in 1959, workers found the log coffin of Fray Juan Jose Padilla, which had made its way to the surface because of the high water table. Pathologists confirmed that the remains were that of the priest, who died in 1756. A concrete foundation was put in place so that Father Padilla could finally rest in peace. (Photograph by Ben Wittick, Palace of the Governors [NMHM/DCA], No. 015588.)

BIBLIOGRAPHY

Curtis, Edward S. *The North American Indian*, volume XVI. Norwood, MA: The Plimpton Press, 1926.

———. *The North American Indian*, volume XVII. Norwood, MA: The Plimpton Press, 1926.

Kantner, John. *Ancient Puebloan Southwest*. Cambridge, UK: Cambridge University Press, 2004.

Kessell, John L. *The Missions of New Mexico Since 1776*. Albuquerque, NM: University of New Mexico Press, 1980.

Ortiz, Alfonso, editor. *Handbook of North American Indians*, volume 9. Washington, DC: Smithsonian Institution, 1979.

———. *Handbook of North American Indians*, volume 10. Washington, DC: Smithsonian Institution, 1983.

Sando, Joe S. *Pueblo Nations: Eight Centuries of Pueblo History*. Santa Fe, NM: Clear Light Publishers, 1992.

———. *Pueblo Profiles: Cultural Identity through Centuries of Change*. Santa Fe, NM: Clear Light Publishers, 1998.

———. "The Silver-Crowned Canes: Symbolism at the Heart of Pueblo History and Society." *La Herencia*. Santa Fe, NM: October 2010.

Simmons, Marc. *Witchcraft in the Southwest: Spanish and Indian Supernaturalism on the Rio Grande*. Flagstaff, AZ: Northland Press, 1974.

Sweet, Jill D. *Dances of the Tewa Pueblo Indians*. Santa Fe, NM: School of American Research Press, 2004.

Warren, Nancy Hunter, and Jill D. Sweet. *Pueblo Dancing*. Atglen, PA: Schiffer Publishing, 2011.

ABOUT THE ARCHIVES

The Palace of the Governors Photo Archives in Santa Fe contain more than one million photographs dating to 1850. This treasure trove of imagery encapsulates the history of New Mexico and the region. From anthropology to archaeology to people, each image provides a piece of the puzzle that tells the story of a time long gone, ensuring that it will not be forgotten.

The earliest collections at the archives came from the Historical Society of New Mexico. Founded in 1859, the society's photograph collection was housed in the Palace of the Governors. Fifty years later, in 1909, the Museum of New Mexico opened its doors, and the historical society continued to house its collection at the palace. In 1977, the society's photograph collection was donated to the State of New Mexico, which oversees the museum system. In addition to this vast collection of photographs, the archives contain thousands of images that were created by major professional photographers of the Southwest. Equally important are the private family photograph collections that have been donated to the museum for the sake of posterity.

The archives are considered one of the most important historical collections in the American West. Adding to the significance of this collection depicting the ethnology of this region are photos from Latin America, the Far East, Oceania, and the Middle East.

The archives collection is as diverse in content and subject matter as the early process of photography, which began in Europe in 1839 with pioneers such as Louis Jacques Mande Daguerre, for whom the daguerreotype is named. Through trial and error, the commingling of light, copper, iodine, mercury, and salt captured the world's first images. Today, the adage "a picture is worth a thousand words" is even more relevant with the explosive growth in digital media that has become a ubiquitous part of our daily lives.

DISCOVER THOUSANDS OF LOCAL HISTORY BOOKS FEATURING MILLIONS OF VINTAGE IMAGES

Arcadia Publishing, the leading local history publisher in the United States, is committed to making history accessible and meaningful through publishing books that celebrate and preserve the heritage of America's people and places.

Find more books like this at
www.arcadiapublishing.com

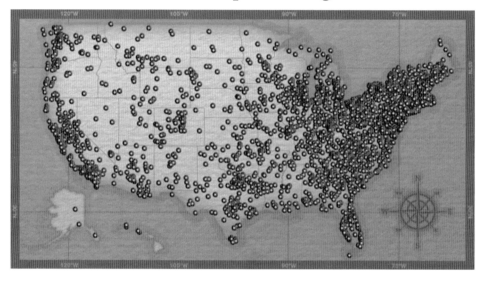

Search for your hometown history, your old stomping grounds, and even your favorite sports team.